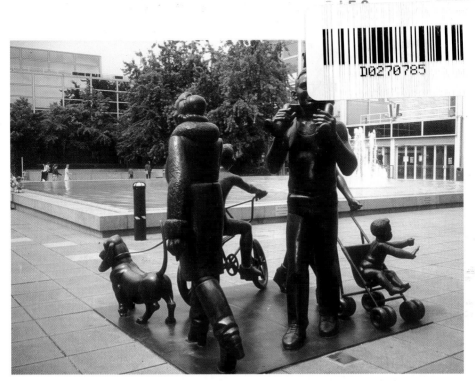

'Vox Pop' (1988), by the sculptor John Clinch (1934–2001), stands in Queen's Square, an outdoor space within the shopping centre at Milton Keynes. It is one of a series by Clinch reflecting his popular and accessible approach to public art, which he described as vernacular sculpture. The original intention was to mount the sculpture on a plinth, but this was omitted to encourage shoppers to examine the figures, which follow each other round in a circle.

Public Art
since 1950

Lynn F. Pearson

A Shire book

Published in 2006 by Shire Publications Ltd,
Cromwell House, Church Street, Princes Risborough,
Buckinghamshire HP27 9AA, UK.
(Website: www.shirebooks.co.uk)

British Library Cataloguing in Publication Data:
Pearson, Lynn F.
Public art since 1950. – (Shire album; 451)
1. Public art – Great Britain
2. Public art – Ireland
3. Art, British – 20th century
4. Art, British – 21st century I. Title
709.4'1'09045
ISBN-10: 0 7478 0642 X.

Front cover: *In the centre of the Port Marine development in Portishead, Somerset, are 'The Angels of Portishead' (Rick Kirby, 2002, mild steel), five female figures about 5 metres (16 feet) in height; they refer to the town's five Second World War radio masts.*

Back cover: *'Big Fish' by John Kindness, 1999, on Donegall Quay, Belfast. See page 70.*

The author is very gra_____Adrian Evans, Denis
Gahagan, Tony Herbei | **EAST SUSSEX** | dy Macfarlane, Chris
Marsden, Jim and Mai | **SCHOOLS LIBRARY SERVICE** | Joan Skinner, Jeremy
Southorn (Heritage 1 | | n, Gill Wright and,
particularly, Penny B | | ir assistance in the
preparation of this boc | |
 The photographs ar | **19-Oct-06** | **PETERS** | s: page 6 (both), from
the author's collection | | ole Museum Service;
page 12 (top), from He | **594409** | 2, 49 (bottom) and 53
(top), by Cadbury Lan | | page 19 (bottom), by
Sue Ross; page 29 (top

Printed in Malta by Gutenberg Press Limited, Gudja Road, Tarxien PLA 19, Malta.

Contents

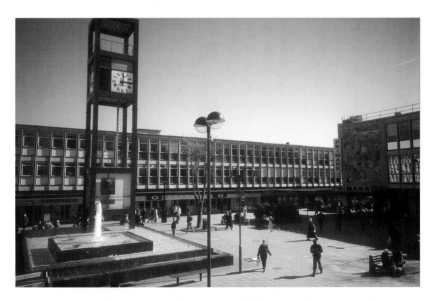

The centre of Stevenage New Town was built during 1957–9 and still retains much of its original decorative work, including a large pictorial tile mural on the former Co-op store on the south side of the Town Square, overlooking the pool.

Draped prettily around a pool in the centre of Horselydown Square, just south of London's Tower Bridge, are several bronze female bathers, part of the sculpture 'Waterfall' (Antony Donaldson, 1991). Donaldson was also responsible for the massive steel head of Alfred Hitchcock, installed at Hackney's Gainsborough Studios in 2005.

Introduction

Public art, as defined in this book, means works of art that are located in public places and are therefore easily viewed. Some artworks that form part of the structure or decoration of buildings are also discussed, as well as a few pieces that are set in buildings such as offices or hospitals that are partially accessible to the public. The focus of the book is on artworks in the environment, including everything from traditional figurative bronze sculptures to abstract works in a wide range of materials, as well as some light and sound installations. Although much public art is of a relatively temporary nature, the book – and especially the selective gazetteer of sites – concentrates on works intended to be permanent, and those that are on display in everyday public spaces rather than sculpture parks and similar areas devoted specifically to artworks. Throughout the text, the date given in brackets following the name of a work indicates its year of installation. Readers should note that artworks may occasionally be removed at short notice, or be otherwise inaccessible.

The 'Angel of the North' (Antony Gormley, 1998) stands on the southern edge of Gateshead and is visible from the main East Coast railway line and several major roads, including the A1. The shape of the sculpture is based on a cast of the artist's own body. The foundations beneath the 'Angel' include eight 20 metres (66 feet) long concrete piles, enabling the figure to resist winds of speeds up to 160 km (99 miles) per hour. It was made by Hartlepool Steel Fabrications Ltd during 1997–8 and erected in Gateshead on 15th February 1998. Its height is 20 metres (66 feet) and the 'wingspan' is 54 metres (177 feet); it is visited by over 150,000 people every year.

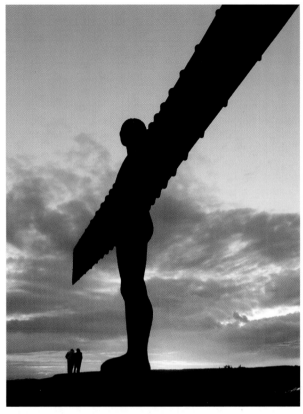

Unlike what might be described as 'gallery art', public art has little collectable value, and artists producing public art have generally been funded through the public, corporate or sometimes private purse. There has been a variety of objectives behind the introduction of artworks to public spaces, and several works have proved controversial, occasionally to the point where schemes have been abandoned before completion or finished artworks have been vandalised, removed or even destroyed. However, the success of Antony Gormley's iconic *Angel of the North* (1998) as a tourist attraction in Gateshead appears to have paved the way for more general acceptance of, and curiosity about, public artworks.

Bringing art to the people

Before the Second World War public art in Britain was largely restricted to monuments, memorials and decorative architectural features integral to buildings. The roots of the modern public-art movement lie in the decade following the war, when the newly popular idea of 'bringing art to the people' encouraged a revival of mural painting and the siting of sculptures in public places, notably at the South Bank Exhibition, part of the 1951 Festival of Britain, where over thirty sculptures and fifty murals were on display, and later in the schools and new towns built during the 1950s. Although most of the South Bank Exhibition murals were painted works for interior locations, covering an outer wall of its Regatta Restaurant, in a prominent position near the exhibition's entrance, was a black and white ceramic mural, *The Waterfall*, an abstract spiral composition by the artist Victor Pasmore.

The success of this work encouraged its makers, Carter's of Poole in Dorset, to expand their mural-making activities and

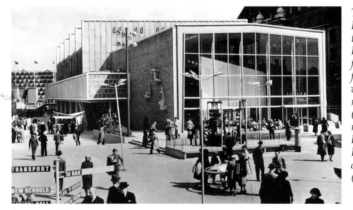

The Power and Production Pavilion at the 1951 South Bank Exhibition. On its façade, to the left of its fully glazed west end, were three concrete reliefs by Karel Vogel (1897–1961) representing 'The Industries: Heavy, Light, Electricity'; they were each about 3.5 metres (11 feet) long.

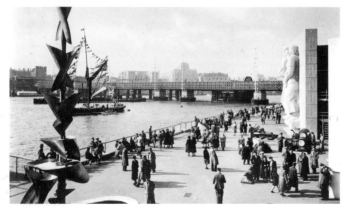

On the outside of the South Bank Exhibition's Sea and Ships Pavilion (right) was the monumental figurative relief 'The Islanders' by Siegfried Charoux (1896–1967). On the left is part of the 14 metres (46 feet) high steel and aluminium 'Water Mobile Sculpture' by Richard Huws.

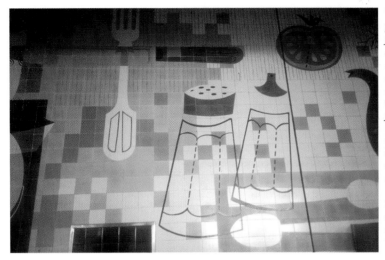

There is now no public access to the former cafeteria in Lewis's store on Ranelagh Street in Liverpool, but the Festival of Britain style tiling, installed for the opening of the cafeteria in 1953, remains. The mural behind the old servery counter is around 20 metres (66 feet) long and 3 metres (10 feet) high and is probably the earliest extant post-war mural made by Carter's of Poole.

they were soon joined by Pilkington's Tiles of Manchester; at least seventeen ceramic murals were installed in Britain between 1953 and 1959, and around fifty more during the 1960s. The majority of designs featured stylised images relating to the commissioning body, for instance the outsize cooking utensils and items of food and drink depicted in Carter's 20 metres (66 feet) long mural carried out for the cafeteria opened in 1953 at Lewis's store in Liverpool. Painted murals were popular in wartime restaurants and had previously been commissioned for John Lewis Partnership stores, since they could easily be replaced as fashion dictated; an exterior tile mural was rather more permanent. Some were on a vast scale, for instance the extraordinary Transport House mural (1959) in Belfast, around 27 metres (89 feet) in height, or the 1958 mural, designed by Gordon Cullen, in Coventry's Precinct, around 18 metres (59 feet) in length. Both of these were pictorial but there were occasional ventures into abstraction, such as the 1958 tile mural designed by William Gordon that covered the whole length of the upper part of Basildon bus station; this was replaced in the early 1980s.

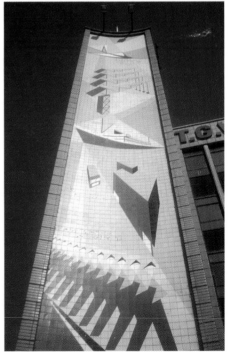

The façade of Transport House (1956–9), High Street, Belfast, is dominated by a ceramic tile mural made by Carter's of Poole showing stylised images of workers in local industries.

On the rear elevation of Sunderland Museum and Winter Gardens, overlooking Mowbray Park, is a striking group of three abstract tile panels designed in 1963 by Walter Hudspith, then Senior Lecturer at Sunderland College of Art. They were the first public artworks to be commissioned in Sunderland, and their designs represent Music, Art and (shown here) Literature.

Even more popular during the 1950s and early 1960s were stand-alone sculptures, their use in schools pioneered in Hertfordshire, Leicestershire and London, where the County Council had commissioned fifty-one works for its schools and housing estates by 1961. However, it was the post-war New Town programme that provided architects and planners with the opportunity to design centres in which artworks were fully integrated with shopping and other urban activities. The pedestrianised heart of Stevenage, the first new town to be designated, was built in 1957–9 and centred on the Town Square with its clock tower, pool and associated sculpture. The Harlow Arts Trust was founded in 1953 and by 1973 there were twenty-seven sculptural works on public sites in that town. Harlow's terraced Water Gardens, constructed in 1958–63 (rebuilt 2002–4), featured an array of standing sculptures by well-known artists and seven rugged fountain heads by William Mitchell, who specialised in sculptural concrete structures. At Peterlee, the artist Victor Pasmore's late-1960s modernist concrete *Apollo Pavilion*, sculpture on an architectural scale, was intended as a focal point for housing in rural surroundings but never gained

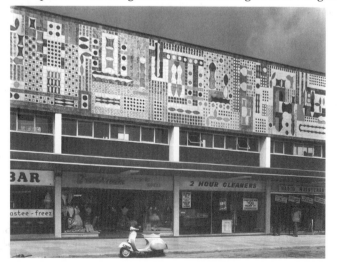

A section of the colourful hand-painted geometric abstract tile mural designed by the potter William Gordon (born 1905), made by Carter's of Poole and installed above the shops at Basildon bus station in 1958; its length was nearly 90 metres (295 feet). It was replaced with a historically themed tile mural in the early 1980s.

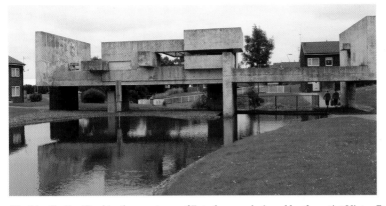

The 'Apollo Pavilion' in the new town of Peterlee was designed by the artist Victor Pasmore (1908–98) and built during the late 1960s. The reinforced-concrete structure is around 6 metres (20 feet) high and was originally decorated with murals, but these are now almost invisible. A minor element of the sculpture, a rounded concrete column, stands in the water in front of the main pavilion.

the affection of the local community, unlike the notorious concrete *Cows* (1978) of Milton Keynes, one of the earlier works in the city's fine collection of sculptures.

David Harding was appointed Town Artist to Glenrothes in 1968 and worked as part of the town's design team as well as with groups of local people to produce artworks. Harding's own work in Glenrothes included several large-scale totem-like concrete sculptures, notably *Henge* (1973) and *Heritage* (1976), but it was his community-related projects that inspired the appointment of town artists at many other new (and old) towns during the 1970s. Skelmersdale (Lancashire), East Kilbride (South Lanarkshire), Glenrothes (Fife) and Livingston (West Lothian) were other new towns in which notable artworks were installed during the 1960s and 1970s; these were often concrete murals lining the pedestrian walkways related to the growing road networks. The stand-alone works in particular were prone to vandalism, one reason behind the removal of several works made for the new town of Peterborough from street locations to the town's sculpture park at Thorpe Meadows, in the Nene Park, after 1978, when the Peterborough Sculpture Trust was set up.

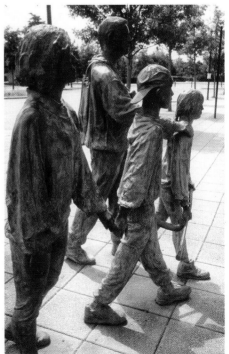

One of the works in the Milton Keynes collection of public art is the life-size figurative bronze 'A Family Sport' (Chris Boulton, 1996), which stands outside the National Hockey Stadium, just north of the Central railway station. The sculpture was cast at Boulton's Bronze Works foundry in Sheffield.

Concrete murals and corporate imagery

Sculptures, along with a wide range of other artworks including murals, engraved glass and metalwork, were prominent in the more lavish civic and university buildings and modernist office developments of the 1950s to 1970s. Notable examples are Franta Belsky's complex bronze fountain (1963) in the courtyard of the Shell Centre (1953–63) on London's South Bank, John Piper's abstract mosaic mural (1960) commissioned for the foyer of Birmingham Chamber of

Commerce and Industry (1958) and John Hutton's engraved glass screens at New Zealand House (1959–63) in London's Haymarket. The sculptural works were often sited outside the main entrance or attached to otherwise plain areas of outer wall, leading to criticism that they had no relationship with their locations. Henry Moore's abstract stone screen (1953), which formed part of the façade of the Time-Life Building in London's New Bond Street, was a spectacular exception to this rule.

The 'River God Tyne' (David Wynne, 1968, bronze) is stationed on the outside of Newcastle upon Tyne's Civic Centre, between the Portland stone tower and the elliptical council chamber. The tower is topped by twelve 1.4 metres (4 feet 7 inches) high bronze seahorse heads, an element of the city's arms; the artist was John McCheyne (1911–82), then Master of Sculpture at the city's university.

David Wynne's anodised aluminium sculpture 'The Spirit of Fire', a reference to the local potteries, was installed outside Lewis's store in Stafford Street, Hanley, Stoke-on-Trent, in 1964. The spiky, 11 metres (36 feet) high figure, known locally as Jack Frost, became part of the Potteries Shopping Centre in 1988.

In the forecourt of Darlington's town hall is the 5 metres (16 feet) high stainless-steel geometric form of 'Resurgence' (1970) by the metal sculptor John Hoskin (1921–90); it was intended to relate to the town's engineering heritage and complement the form of its new town hall, as well as symbolise the town's progress.

The architectural profession's dislike of working with independent artists, combined with the wish to incorporate some minimal forms of ornament into their buildings, led to experiments from the early 1960s with various decorative wall finishes, including sculptured concrete, *ciment fondu* (cement with a high aluminium content), metal and fibreglass, although a few substantial external pictorial tile panels, mostly on historical themes, continued to be installed, for instance Adam Kossowski's *The History of the Old Kent Road* (1965) at North Peckham Civic Centre. William Mitchell's massive, highly textured abstract concrete reliefs appeared on a Wandsworth local-authority housing estate in the early 1960s and then became particularly popular in the north of England during the late 1960s and early 1970s. One of his largest works was the series of 3 metres (10 feet) high panels (1968) stretching around the open pedestrianised area inside the Hockley Circus roundabout in north-west Birmingham, while the most exotic was the complete façade of the Three Tuns (1966), a Coventry public house. Charles Anderson's 122 metres (400 feet) long stylised

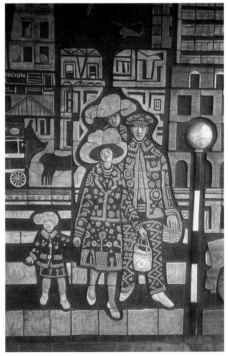

On the exterior of the former North Peckham Civic Centre (1962–7, later a Pentecostal church), Old Kent Road, in south London is the large polychrome ceramic frieze 'The History of the Old Kent Road' by the sculptor Adam Kossowski (1905–86). Depicting local historic scenes in high relief, it was designed in 1964 and completed in 1965.

Left: *The tile mural designed by A. B. Read for the offices of the Shell Refining Company Ltd at their Shellhaven base in Essex shows typical 1960s corporate imagery. Similar murals were commissioned from the large tile manufacturers by bodies including utility companies, local authorities, shops, brewers, schools and universities.*

Right: *A typical abstract concrete relief mural by William Mitchell in Burgess Street, Sheffield, dating from 1972. Mitchell's large-scale mural work included the high-relief concrete abstract covering both end façades of the eight-storey County Police Headquarters (1964–7) in Chester. He worked in a variety of materials, using a mixture of concrete and fibreglass for the fourteen 'Stations of the Cross' (1973) in Clifton Cathedral, Bristol.*

figurative concrete mural on the outside of the Thompson Centre in Burnley was one of the longest murals in Britain when completed in 1973.

Concrete was also used by Henry and Joyce Collins in their large-scale mural work of the 1970s, but generally in combination with more colourful materials including mosaic, stone and *ciment fondu*. Their murals, which they produced for Sainsbury's and British Home Stores as well as the subways of their home town, Colchester, normally portrayed local historical themes. A series of about twelve ceramic and stone mural works by Philippa Threlfall and Kennedy Collings was commissioned by the Bradford & Bingley Building Society in the 1970s, and their locally themed, often figurative murals were popular with shopping centres and offices, mostly in the south of England. Their largest work, the 26 metres (85 feet) long *Life in West Riding* (1969), made for the restaurant at Leeds-Bradford Airport, has been lost to redevelopment. Several other artists produced smaller-scale historical works for the new supermarkets and offices of the 1960s and 1970s, but a quite

Right: 'Newcastle through the Ages' (1974), in Newcastle upon Tyne's central shopping area, was one of a series of concrete murals designed by the artists Henry Collins (1910–94) and his wife Joyce Pallot (1912–2004) and made in their home town, Colchester. Five similar historical murals by Henry and Joyce Collins can be seen in Stockport's Merseyway shopping precinct (1978).

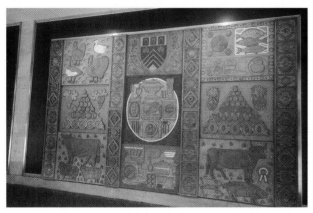

Left: The redevelopment of Gloucester from the late 1960s included the widespread installation of historical murals and abstract reliefs, mostly in concrete but also using cast resin. Examples from around 1970 and 1980 (by David Gillespie Associates) occur on the main shopping street, Eastgate Street, and at Sainsbury's on Northgate Street, which has murals by Henry and Joyce Collins (1970).

Right: The 18 metres (59 feet) long 'Greenwich Mural' (1972) in Woolwich Road, Greenwich, was commissioned from Philippa Threlfall (born 1939) and Kennedy Collings (1933–2002) for an external wall of Greenwich District Hospital, which was completed in the late 1970s but closed in 2001. The mural, whose theme is the maritime history of Greenwich, was one of the earliest large-scale murals produced by Threlfall and Collings.

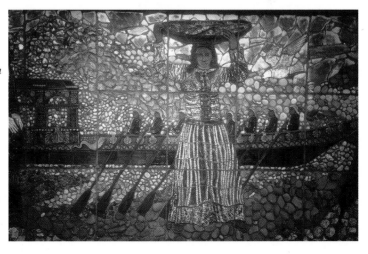

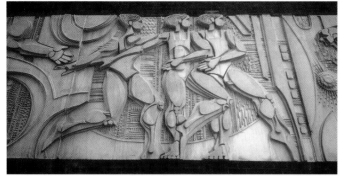

The designer of the 122 metres (400 feet) long concrete mural (1973) that stretches along the entire side of the Thompson recreation centre in Red Lion Street, Burnley, was the Scottish artist Charles Anderson (born 1936), who was well known for his mural work from the 1960s to the 1980s.

different approach was taken by the artist John Piper with his early 1960s abstract designs for the external first-floor panels of what is now known as the Piper Centre in Fulham; these were vividly colourful, in complete contrast to the sometimes dreary concrete murals of the time. Also abstract, but on a huge scale, are the massive ceramic pieces entitled *Articulation in Movement* (Fritz Steller, 1970) on the exterior of Huddersfield's Queensgate Market. Although this provided a modernist response to the architecture of the time, it was followed by few similar sculptures, probably because of a combination of cost constraints and the sheer complexity of producing monumental works.

From the late 1960s, art integrated into architecture generally

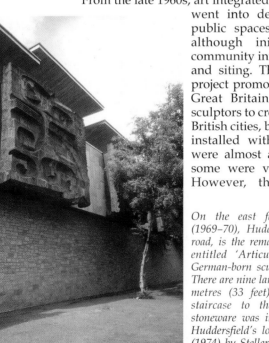

went into decline, while artworks in public spaces became more common, although initially there was little community involvement in their creation and siting. The 'Sculpture in the City' project promoted by the Arts Council of Great Britain in 1972 invited sixteen sculptors to create works for sites in eight British cities, but the resulting sculptures, installed without public consultation, were almost all unappreciated; indeed, some were vandalised and destroyed. However, the project did provoke

On the east façade of Queensgate Market (1969–70), Huddersfield, facing the inner ring road, is the remarkable series of ceramic murals entitled 'Articulation in Movement' by the German-born sculptor Fritz Steller (born 1941). There are nine large panels and a free-standing 10 metres (33 feet) high sculpture pierced by a staircase to the market; their rusty-brown stoneware was intended to weather better than Huddersfield's local stone. Another large mural (1974) by Steller can be found inside Southend's Central Library.

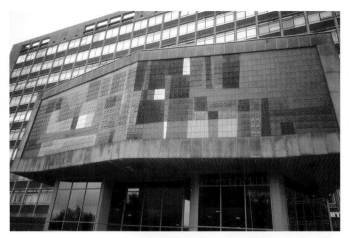

The University of Bradford's Richmond Building in Richmond Road, Bradford, dates from the late 1960s. Above its main entrance is a bold ceramic mural, about 15 metres (49 feet) long by 5 metres (16 feet) high, with an abstract geometric design carried out in relief tiles.

Art could be integrated with architecture in the form of lettering, as in the cast-concrete letters (1973) by Richard Kindersley spelling out the name of the Cathedral Church of Saint Peter and Saint Paul in Pembroke Road, Clifton, Bristol. Each letter is 45 cm (18 inches) high and the whole work is 25 metres (82 feet) long.

discussion about the use of materials robust enough to stand up to harsh weather conditions, and the construction of works, including landforms, for specific sites rather than for gallery exhibition. One of the two Birmingham works, *King Kong* by Nicholas Monro, a 5.5 metres (18 feet) high fibreglass ape sited in the Bullring, produced a reaction common to many subsequent large public-art pieces: immediate public outcry against the work followed by the slow growth of affection for it. However, the city council refused to purchase *King Kong* after its six-month sponsored period had elapsed, and it was removed.

Public art was kept alive during the decade following the mid 1970s with projects related to urban developments, notably the proliferation of offices, hospitals, supermarkets and underpasses, all with blank walls requiring some form of decoration, often with a local theme. However, although collaboration between artists and architects grew from the early

Below: *On the Lower Maudlin Street façade of the Bristol Eye Hospital is 'The Creation', five massive carved-brick reliefs by sculptor Walter Ritchie (1919–97) including 'Animal Life', with a giraffe, kangaroo and a multitude of other creatures cunningly interwoven. When installed in 1986, these panels were the largest non-reinforced brick reliefs ever carved.*

A small section of the vast Armada Way underpass tile mural, Plymouth (1990, removed 2004), which was designed by Edward Pond and executed by Kenneth Clark Ceramics. The installation was 91 metres (299 feet) long and its theme was the city's naval history.

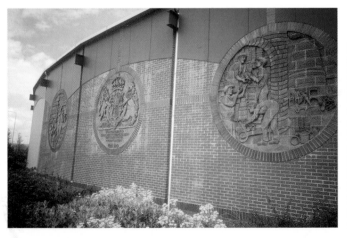

Brannam's Pottery works moved from the centre of Barnstaple to the Roundswell Industrial Estate, on the town's southern edge (just off the A39), in 1989. The exterior of the new works sports three large, circular carved-brick panels designed by the artist Jeffrey Salter. They show scenes from the old works and a royal coat of arms.

Barry Flanagan's 'Leaping Hare on Crescent and Bell' (1988, bronze) in Broadgate Square in the City of London is nearly 4 metres (13 feet) high; just to the south in the Octagon is the much more obtrusive rusted steel tower 'Fulcrum'. Both were among the earlier works bought or commissioned by Broadgate's developers, Rosehaugh Stanhope.

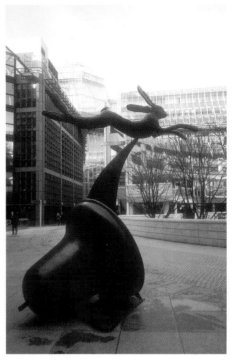

1980s, it was not until the mid 1980s that local authorities and developers regularly began to commission artworks for new buildings. The Percentage for Art campaign, arguing that publicly funded building schemes should require a percentage of the budget to be spent on art, was promoted from 1989 by the Arts Council. Over fifty local authorities had adopted such a policy by 1992, leading to a dramatic increase in the amount of public art produced during the 1990s.

The introduction of artworks by the property company Rosehaugh Stanhope into their commercial development of Broadgate in the City of London from 1986 onward proved highly influential, although this scheme was not carried out under a strict 'percentage for art' policy but rather a more flexible arrangement dictated by the interests of the company's directors. An international array of artists created a varied collection of generally large-scale works in response to the huge size of the buildings around them; the whole was judged a success, and a similar programme of artworks was instituted at the financial centre of Canary Wharf in 1987. By the mid 1990s public and private office, housing and shopping developments of all sizes frequently included artworks. They were seen as advantageous in environmental terms, and added to the positive profile of

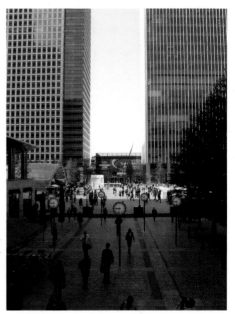

One of many artworks at Canary Wharf in east London is 'Six Public Clocks' (Konstantin Grcic, 1999), which stands just south of the main group of towers on the edge of Nash Court. On the far side of Jubilee Park, which leads east from this public space, are Montgomery Square and the bronze 'Centauro' (Igor Mitoraj, 2002), a third and specially cast version of the centaur; the first was made in 1994.

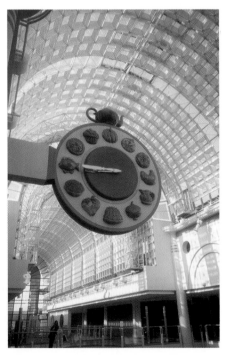

Above left: *The openwork bronze lettering making up the gateway to the British Library at St Pancras (completed in 1997) and spelling out its name is by David Kindersley and Lida Lopez Cardozo Kindersley; beyond, in the library courtyard, is the monumental 'Newton' (Eduardo Paolozzi, 1997).*

Above right: *Dotted around The Scoop, next to London's City Hall on the south bank of the Thames, are Fiona Banner's five giant bronze full stops (2004) in different fonts including 'Full Stop Courier'. The abstract, site-specific sculptures are intended to punctuate the space and cause passers-by to pause or stop.*

Left: *The location of the food court inside the Bentall Centre (1992), Clarence Street, Kingston upon Thames, is indicated by the 'Bentall's Clock', which features ceramic number markers in the form of edible items such as cakes and fruit; it was designed by the ceramicist Kate Malone.*

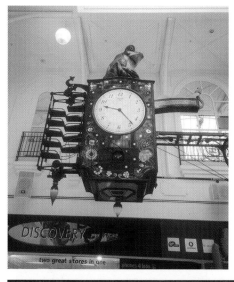

Inside Telford Shopping Centre, dominating Sherwood Square, is the 'Telford Time Machine' (Kit Williams, 1996), a large novelty clock topped by a huge green frog; its casing is faced with colourful hand-made ceramic tiles produced at nearby Jackfield.

Below: *Part of the piazza outside Trencherfield Mill at Wigan Pier is floored with a set of giant white concrete dominoes, some of which stand on end and serve as seats. They were made in 1998–9 by the sculptor Russ Coleman (born 1964), who also designed Carlisle's 'Steel Wall' (2001), which forms part of the walkway linking Carlisle Castle and the city centre.*

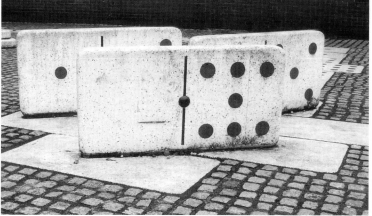

the company or location. The area around London's City Hall, near Tower Bridge (Southwark), provides a good example; it is known as The Scoop, and scattered around it are five sculptures by Fiona Banner of giant full stops in different fonts. The developers of Port Marine, a disused power-station site at Portishead in Somerset, appointed an artist in residence, who contributed to an extensive public art programme due for completion in 2010, while the site of the former sewage-treatment works in Worcester Park (London Borough of Sutton) was developed from 2004 as The Hamptons, with the addition of a sculpture trail and a large-scale land artwork.

Art and regeneration

From the mid 1990s, public artworks were often promoted as environmental improvements in areas needing regeneration, from ageing seaside resorts and moribund town centres to old industrial sites, including several former working ports such as Newcastle upon Tyne and Sunderland. Funds supplied by the National Lottery, through the Millennium Commission and the national arts councils, helped many such projects, notably the redesign of the Playhouse Square in Nottingham featuring Anish Kapoor's spectacular *Sky Mirror* (2001); this was supported by a lottery grant of £910,000 through Arts Council England (ACE). Other town regeneration schemes included the pedestrianisation of Kilmarnock's main street, King Street,

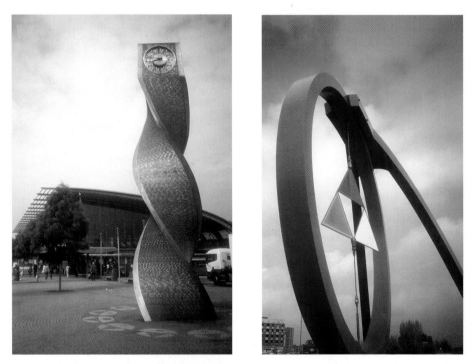

Above left: *On the forecourt of Stratford station, Great Eastern Road, in the London Borough of Newham, is the 10 metres (33 feet) high 'Time Spiral' (Malcolm Robertson, 1996, stainless steel), a landmark sculpture featuring three clocks. Robertson was Town Artist at Glenrothes during the 1980s, following David Harding in the post.*

Above right: *The centrepiece of Newport's Baltic Wharf, a riverside walk created in the late 1980s, is 'Steel Wave' (Peter Fink, 1990), a 15 metres (49 feet) high and 35 metres (115 feet) long geometric sculpture that is a tribute to the town's steelworkers and seafarers.*

Successful redevelopment of Bristol's waterfront included the creation of Millennium Square, in which there are several artworks, including the swimming dogs 'Bill and Bob' (Cathie Pilkington, 2000, bronze), whose original companion Jasmine was stolen. The square's centrepiece is an expansive water feature, 'Aquarena' by William Pye.

Right: Outside Bristol's Explore science centre on Anchor Road, in the redeveloped Canon's Marsh area, is the colourful cone of 'Small Worlds' (Simon Thomas, 2000, cement and glass fibre), a tribute to the Bristol-born physicist Paul Dirac.

Children enjoy playing on the three cast-iron greyhounds of 'Racing Ahead' (Irene Brown, 1995) in the High Street, Stockton-on-Tees. Across the road, overlooking the river from the end of Silver Street, is the kinetic sculpture 'Aeolian Motion' (2001), designed and made by the blacksmith Phil Johnson of Ratho in Midlothian.

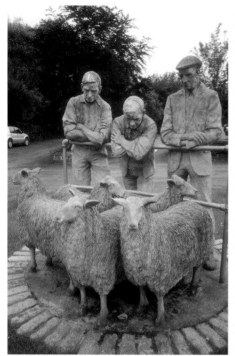

Hatherleigh's 1997 town centre enhancement scheme included the installation of several artworks, notably 'Sheep in Hatherleigh Market' by the sculptor Roger Dean, which stands beside the old sheep market at the bus turning circle.

around 1997, with humorous street sculpture – quirky bronze heads and strange animals – by Shona Kinloch. In Shrewsbury's west end at Mardol Head, the *Darwin Gate* (Mark Renn and Mick Thacker, 2004) became the first public artwork to be commissioned in the town for over a century. The structure, which commemorates the birth of Charles Darwin in Shrewsbury, is a 7 metres (23 feet) high tripartite gateway with associated seating and paving.

The Tyne and Wear Development Corporation (TWDC) commissioned a series of mainly small-scale artworks in 1995–7 during the redevelopment of Newcastle's quayside, the most notable being the 5 metres (16 feet) high *Blacksmiths' Needle* (1996), a conical openwork tower of cast-iron objects with a maritime theme. After the dissolution of the TWDC its arts scheme was taken over and extended as 'Art on the Riverside', encompassing sites in Newcastle, Sunderland and North and South Tyneside. This was the most extensive programme of public art in the United Kingdom and received £3.5 million of lottery funding from ACE as well as a total of £2.7 million from the public and private sectors. Its output in Sunderland focused on St Peter's Riverside, with a series of works sited along the walkway on the north bank of the Wear. Cardiff's waterfront was transformed during the 1990s with public artworks in a variety of materials and styles, from figurative bronzes to

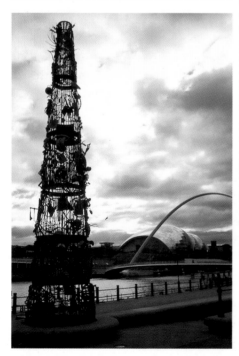

The multitude of objects making up the 'Blacksmiths' Needle' (1996) on Newcastle upon Tyne's quayside promenade were made during public 'forge-in' sessions carried out around Britain. The cone's six sections relate to the senses, including the mysterious sixth.

Outside the entrance to Belfast's Waterfront Hall is the life-size bronze group 'Sheep on the Road' (1991) by the Belfast artist Deborah Brown (born 1927). It stood in the city's sculpture garden until bought by the Laganside Corporation in 1999 and sited on the regenerated quayside at Lanyon Place.

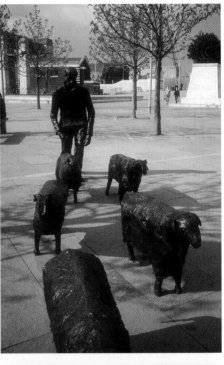

brick benches and an abstract steel water feature, being installed during 1993–6 and following completion of the Cardiff Bay Barrage in 1999. In Belfast, the Laganside Corporation was set up in 1989 to regenerate the quayside area and installed several artworks during 1999–2001, the most popular of which is the 10 metres (33 feet) long ceramic *Big Fish*.

The construction of Southport's new sea wall and promenade began in 1997, allowing artworks to be incorporated into the improved sea defences, as at Morecambe, whose Tern Project started in 1994, and rather more extravagantly at Blackpool, where the windswept South Shore Promenade was reborn as the Great Promenade Show in 2001; the artworks included a huge mirrorball and the *High Tide Organ* (Liam Curtin and John Gooding), which produces musical chords resulting from incoming tidal movements. Bridlington's award-winning South Promenade improvement scheme was completed in 1998 and included new beach huts, offices, seating, lighting and paddling pools, as well as incorporating text relating to the town into the paving as the *Nautical Mile*. In Lowestoft, the driving force behind the development of the Maritime Art Trail in 2001 was the need to improve the image of the resort and encourage tourists to explore the town. Small-scale works were installed in the 'Scores' (narrow

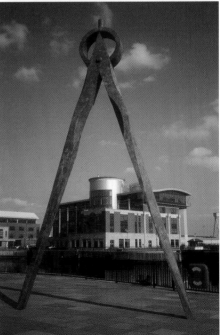

Standing beside Belfast's Clarendon Dock is the 8.3 metres (27 feet) high 'Dividers' (Vivien Burnside, 2001, bronze and stainless steel), a giant version of the simple hand-held tool.

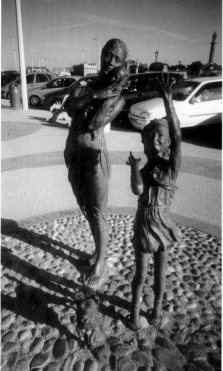

passageways leading down to the sea), a mural carried out in the Market Place, and larger works installed at Ness Point and around the South Beach promenade; the last included *St Elmo's Fire* (David Ward), steel masts topped by randomly flickering lights on the town's two piers.

The rejuvenation of Whitehaven's waterfront, completed in 2001, involved the commissioning of much maritime-themed artwork, including whale-tail seats, fish sculptures and jolly fish-shaped bicycle stands, particularly appropriate as the town is one of two starting points (the other is Workington) for the Sea to Sea (C2C) cycle path, which ends at Sunderland or Tynemouth; the start of the path, at a slipway on Whitehaven's quayside, is marked with a metal sculpture by artist-blacksmith Chris Brammall. The C2C forms part of the National Cycle Network, developed by the charity Sustrans, whose 'Art and

Above: *The life-size bronze statue 'Welcome Home' by Anita Lafford on the seafront at Fleetwood dates from the Lancashire resort's regeneration scheme, which was carried out around the late 1990s; it is intended to celebrate the lives of local fishermen and their families.*

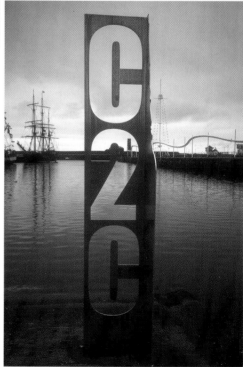

Chris Brammall's stencil-like stainless-steel sculpture on Whitehaven's harbour slipway, marking the start of the C2C cycle path, is partly submerged at high tide. Nearby are several nautically themed artworks installed during the harbour improvement programme of 1998–2001, including the 'Millennium Wave', which runs along Lime Tongue quay to the 'Crow's Nest', an illuminated mast.

Left: *The 'Imago' gateway (William Pym, galvanised steel) at Longbenton, just east of Newcastle upon Tyne, was commissioned by Sustrans and erected in 1996 on a cycle path running through the Rising Sun Country Park. The gate itself takes the form of a moth, while the cocoon-like entrance structure carries text from 'The Healing Spring' by the poet Kathleen Raine (1908–2003), who was brought up in rural Northumberland, about 32 km (20 miles) north-west of Newcastle.*

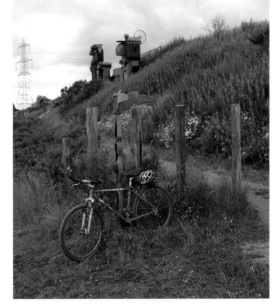

Above: *The massive 'Old Transformers' stand east of Consett on the C2C cycle path. In the foreground is a red-painted Millennium Milepost of the type designed by Andrew Rowe, which can be found throughout the National Cycle Network. It can have up to four directional arms and carries imagery based on the industrial and nautical heritage of Swansea.*

Left: *The most commonly seen of the Sustrans Millennium Mileposts is the version designed by Jon Mills, 'The Fossil Tree', seen here on the C2C cycle route near Rowlands Gill, County Durham; its fossil-based relief motifs relate to the passage of time.*

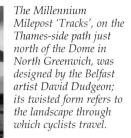

The Millennium Milepost 'Tracks', on the Thames-side path just north of the Dome in North Greenwich, was designed by the Belfast artist David Dudgeon; its twisted form refers to the landscape through which cyclists travel.

the Travelling Landscape' programme has introduced a wide range of public artworks into rural as well as urban locations. They range from sculptured landforms such as the *Jolly Drover's Maze* (Andy Goldsworthy, 1989) at Leadgate, County Durham, through murals and seats in a wide variety of materials, to large three-dimensional works like the towering brick *Fish on its Nose* (Doug Cocker, 1993) at Fishponds, Bristol, and *The Old Transformers* (David Kemp, 1990) on the C2C east of Consett. In addition, around one thousand *Millennium Mileposts*, cast-iron signposts decorated with complex motifs relating to time, the seasons and the zodiac, have been sited throughout the cycle network since 1995. The mileposts are about 2 metres (7 feet) high and have four different designs, by artists from England (Jon Mills), Scotland (Iain McColl), Wales (Andrew Rowe) and Ireland (David Dudgeon).

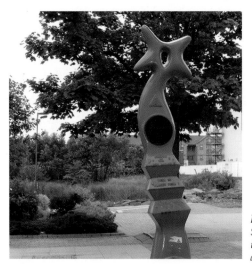

Behind Middlesbrough's town hall, on Russell Street, is a Millennium Milepost designed by the Scottish sculptor Iain McColl and known as 'The Cockerel'.

Landmark sculptures

The vogue for very large-scale landmark artworks, normally erected with the intention of bringing publicity to a specific area, has its roots in a gallery sculpture made in 1983 by the Scottish artist David Mach (born 1956), who is best known for working with multiples of mass-produced objects. His first big public sculpture was *Polaris*, a life-size replica of a submarine made from six thousand rubber car tyres and located outside the Hayward Gallery on London's South Bank walkway. It was intended as a protest against the nuclear arms race but lasted only around a week before being destroyed by an arsonist. The combination of its sheer size and its display in a public place, along with its untimely end, meant *Polaris* made a significant public impact. However, there was still much suspicion regarding the commissioning of large-scale iconic works, although David Mach's landmark brick sculpture *Train* was completed on the outskirts of Darlington in 1997. Its location, beside a busy road at the back of a supermarket (one of the project's sponsors), appears to have limited its public appeal.

During the 1980s the sculptor Antony Gormley carried out development work over a period of five years for Leeds City Council on the *Leeds Brick Man*, a proposal for a 55 metres (180 feet) high figure to be erected on waste ground near Leeds railway station. He produced a model of the sculpture, an upright man with hands at his sides, in 1986, but there were many protests and the project was eventually denied planning permission. It can now be seen as a forerunner of Gormley's *Angel of the North* (1998), the 20 metres (66 feet) high and 54

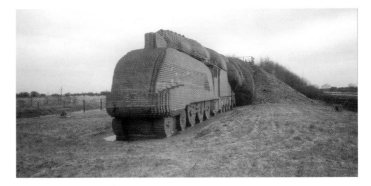

On the eastern outskirts of Darlington, at the Morrison's shopping complex near the junction of the A66 and A67, is the landmark sculpture 'Train', designed by the artist David Mach and constructed from around 185,000 bricks in 1997. The brick train, which has a hollow interior, stands near the route of the original Stockton & Darlington Railway; it was said to be the largest single sculpture in Britain when built.

metres (177 feet) wide humanoid steel figure that stands on a hill at the southern fringe of Gateshead. The idea of this landmark work originated around 1990 with Gateshead Council, whose public-art programme began in 1986. Antony Gormley's proposal was chosen for the site in 1994, and he then worked with engineers Ove Arup & Partners to realise the project, which was initially unpopular with local people.

It gained National Lottery funding in 1996 and was made by Hartlepool Steel Fabrications Ltd during 1997–8; erection of the *Angel* took place over a single weekend in February 1998, since when it has become an instantly recognisable symbol of the town and region, and a popular tourist attraction. The fact that the project was brought to a successful conclusion raised the profile of the town internationally and helped Gateshead Council to gain further arts funding. Other councils and development bodies soon realised that landmark public artworks could provide positive benefits, particularly in terms of increased public awareness and tourist visits, but projects often remained unrealised, for instance the 1999 proposal for a 30 metres (98 feet) high stainless-steel herring sculpture on the quayside at Great Yarmouth.

Landmark artworks that have been created since 1998 include the *Willow Man* (2000) and his replacement following fire, *Willow Man II* (2001), beside the M5 at Bridgwater, Nottingham's *Sky Mirror* (2001), the *Dublin Spire* (2003), and *B of the Bang* (2005) outside the City of Manchester Stadium. Portsmouth's architectural artwork cum viewing platform, *Spinnaker Tower*, opened in 2005, as did the twin 18 metres (59 feet) high towers of Blackpool's Central Gateway. These triple-slab concrete structures, the tallest climbing towers in the United Kingdom when built, also act as landmark artworks and spell out the resort's name. Among similar large-scale projects were the *Scarborough Wave* and Bolton's *Spirit of Sport*. When complete, the spectacular 84 metres (276 feet) long and 10 metres (33 feet) high *Scarborough Wave* will signal the completion of coastal-defence works along the resort's Marine Drive. The white-coated steel structure, resembling a breaking wave and emitting sound when the wind blows, is intended as a tourist attraction but was still under

In Nottingham's Playhouse Square stands the spectacular 'Sky Mirror' (Anish Kapoor, 2001); it was made in Finland from stainless steel, which was then shipped to the United Kingdom for polishing. The mirror is mounted on a plinth cum water feature, and the reconstructed square also includes new paving and specially designed seating.

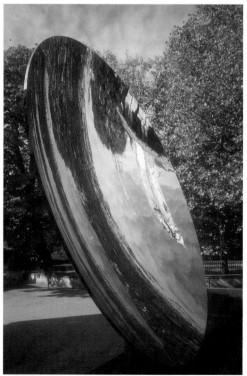

Portsmouth's £35 million landmark 'Spinnaker Tower', opened in 2005 and designed by Scott Wilson Advanced Technology Group, is the focal point of the regeneration of the city's waterfront. Internal and external lifts carry visitors to three viewing decks, the highest of which, the Crow's Nest, is 100 metres (361 feet) above ground level.

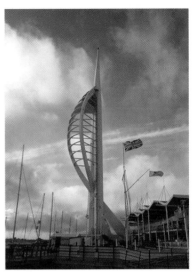

discussion at the time of publication. The 26 metres (85 feet) high *Spirit of Sport*, unveiled in 2005, stands on a roundabout near the Bolton Wanderers football ground, the Reebok Stadium at Horwich. Intended as a tribute to the town's sporting achievements, the giant trophy is faced with nearly a thousand images of local sports players; the competition-winning design was by Terry Eaton and Jem Waygood. The 15 metres (49 feet) wide steel *Sky Bowl* (Pal Svensson) would overlook the city of Durham from a nearby hillside and is intended to improve the profile of the city and region. Its concept has been agreed but funding and practical implications were still being considered at the time of publication.

None of these early large-scale works was sited in the east of England, and in 2003-4 a design competition was organised by the East of England Development Agency to find an iconic landmark that would bring economic benefits and recognition to the region. Four entries were selected for further feasibility studies, including undersea sculptures at Dunwich, a man-made reef off the east coast and the *Bridge of Reeds*, a reed bridge crossing the A14 on the eastern edge of Cambridge and giving foot and cycle access to Wicken Fen, a large area of traditional fenland. Construction of the bridge, a 36 metres (117 feet) high sculptural form inspired by the surrounding landscape, is planned for 2008.

The longest of the 180 tapering spikes that make up Thomas Heatherwick's 'B of the Bang', at the City of Manchester Stadium, measures 35 metres (115 feet) in length. The hollow steel spikes are arranged in elliptical groups radiating from a central point that is 22 metres (72 feet) above the ground.

Stretching along the front of Hulme Library and Adult Education Centre, Stretford Road, just south of Manchester city centre, is the 'Hulme Millennium Mural', which was unveiled in 2002. It took two and a half years to make and used over 2 tonnes of clay; it was the work of Hulme Urban Potters, a collective of students and tutors based at the Centre.

Public art in the twenty-first century

The dawn of the twenty-first century brought with it a boom in public artworks created to celebrate the Millennium, many of them carried out by community groups, for instance the *Hulme Millennium Mural* (2002), an irregularly shaped ceramic mural over 27 metres (89 feet) in length mounted on the front of Hulme Library, Stretford Road, Manchester. Its bold, colourful images, including the nearby Hulme Arch of 1997, show the history of Hulme and its regeneration; the mural took two and a half years to make. The Millennium tile mural *Wrexham Past and Present* (2000) at Wrexham Library included the work of 1200 local schoolchildren, while 101 Folkestone people, each born in a different year of the twentieth century, contributed to *Like the Back of My Hand* (2004), a mural located at the town's Central Station.

In contrast to these generally small-scale and collaborative works, traditional figurative statues by individual sculptors

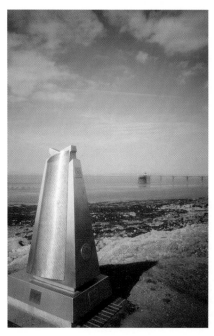

Clevedon's Millennium Monument stands on the promenade at Elton Road, just south of the town's pier. Set into the stainless-steel obelisk are small reliefs of local scenes. Although initially controversial, the sculpture eventually proved to be a popular vantage point.

The 'Cocking History Column' depicts scenes from the West Sussex village's history on a spiral of bronze plaques. The Millennium work was made by local people under the direction of sculptor Philip Jackson, also from Cocking, and was unveiled in 2005.

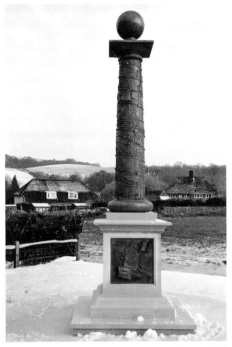

became popular again from the late 1990s, and there was also a resurgence of interest in more formal larger-scale memorial and commemorative works. One of the best-known figurative bronze statues is *Eric Morecambe* (1999) by the Barnsley sculptor Graham Ibbeson, which stands in characteristic pose on Morecambe's promenade and has become a tourist attraction in its own right. Ibbeson has also produced bronzes of *William Webb Ellis* (1997) for Rugby, *Cary Grant* (2001) in Bristol's Millennium Square, *The Jarrow March* (2003) for a shopping precinct in Jarrow and *Arthur Aaron VC* (2001) for a site in front of the West Yorkshire Playhouse at Leeds.

The three-part bronze figurative work 'Man with Potential Selves' (2003) by Sean Henry (born 1965) stands at the south end of Newcastle upon Tyne's Grainger Street, opposite the railway station. It comprises three views of the same 2.5 metres (8 feet) tall man, standing, walking and apparently floating, and is one of several works by Henry on the theme of Everyman and the human condition.

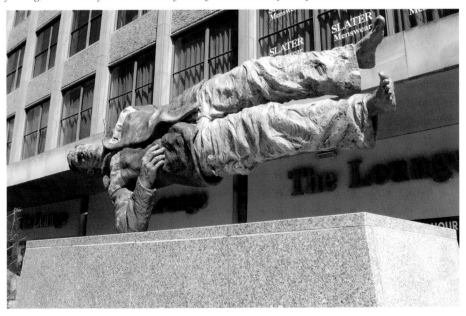

The 'Animals in War Memorial' by the Somerset sculptor David Backhouse (born 1941) stands on the eastern edge of Hyde Park in London. It depicts and commemorates the huge variety of animals that have been used by troops in wartime, from elephants and horses to dogs, pigeons and even glow-worms, used in the First World War to help soldiers read maps. The memorial's curving stone wall is intended to symbolise the arena of war.

Aaron was the city's only winner of the Victoria Cross during the Second World War and was selected by a poll of several thousand local people to be the subject of their Millennium sculpture. Philip Jackson's bronzes of *Sir Matt Busby* (1998) at Old Trafford, Manchester, and *Champions* (2003), a group of four of the 1966 World Cup winning team located near West Ham's ground, Upton Park, confirm the continued popularity of statues of sporting heroes. Philip Jackson was also commissioned to make a twice-lifesize bronze statue of *Bobby Moore* (1941–93), the captain of the triumphant team, to stand at the main entrance to the new Wembley Stadium. The statue of *Cardinal Hume* (Nigel Boonham, 2002), outside St Mary's Roman Catholic Cathedral in Newcastle upon Tyne, was funded by public subscription and quickly became a landmark, as did *Harold Wilson* (1999) outside Huddersfield's railway station and *Desperate Dan* (2001) on Dundee's High Street.

On a larger scale, public support helped the *Memorial to Women of World War II* gain planning permission, and the National Heritage Memorial Fund contributed nearly £1 million towards its cost. The 7 metres (23 feet) high bronze by John W. Mills, showing seventeen different uniforms, was unveiled in Whitehall in July 2005. The *Battle of Britain Monument* (Paul Day, 2005), a massive figurative bronze about 25 metres (82 feet) in length, which stands on the Victoria Embankment to the north of Westminster Bridge, was funded entirely by public donations. On a similar scale is the *Australian War Memorial* (Janet Laurence, 2003) at London's Hyde Park Corner, which comprises a curving wall formed from 540 pieces of grey-green granite inset with 24,000 names of towns and forty-seven battle sites. Also in Hyde Park, just to the north at Brook Gate, is the *Animals in War Memorial* (David Backhouse, 2004), a 3 metres (10 feet) high bronze of a stallion together with smaller bronzes of two mules and a dog approaching an 18 metres (59 feet) wide curved wall of Portland stone carved with low reliefs of animals.

Public artists during and after the Millennium did not restrict their works to traditional forms and materials, but also included

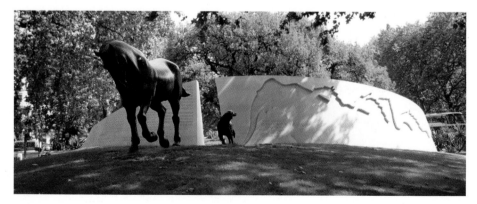

The 17 metres (56 feet) high lighthouse at Trinity Buoy Wharf, overlooking Bow Creek near Orchard Place, was built in 1864–6. The Millennium Dome dominates the view from its lantern, in which Jem Finer's strange, time-related composition 'Longplayer' can be heard; it is intended to play continuously until the next millennium.

experiments with sound and light. Jem Finer's computer programme cum musical composition *Longplayer*, an exploration of time created during 1995–9, began playing in the lighthouse at Trinity Buoy Wharf, Orchard Place, just east of East India Dock, Tower Hamlets, on 31st December 1999 and is intended to play continuously, without repetition, until 31st December 2999, whereupon it should begin again. Peter Freeman's *Luminous Motion* (2002), a 6 metres (20 feet) high mirrored stainless-steel tower, stands in the grounds of Winchester Cathedral; the sculpture's five hundred fibre-optic light points change colour according to text messages received from the public. Freeman used similar light effects in a landmark sculpture sited near the M5 at Weston-super-Mare to mark the gateway to the south-west. *Travelling Light* (2004) is a 13 metres (43 feet) high stainless-steel column whose two thousand lights are programmed to change colour daily and for special occasions such as Valentine's Day, when it shows pink hearts. Other artists dispensed with the idea of static sculpture altogether; the installation *Bins and Benches* (Greyworld, 2005), sited at the Junction, Cambridge, consists of mobile street furniture.

The history of post-war public art has not been without difficulties, generally resulting from differing definitions of the artworks themselves. Rachel Whiteread won the 1993

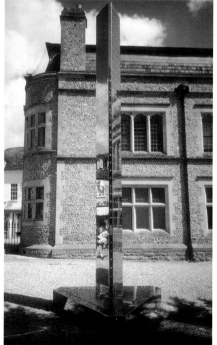

Close to Winchester Cathedral is the interactive sculpture 'Luminous Motion' by the Cornwall-based light artist Peter Freeman (born 1956); the initial inspiration for his work was Blackpool's annual illuminations.

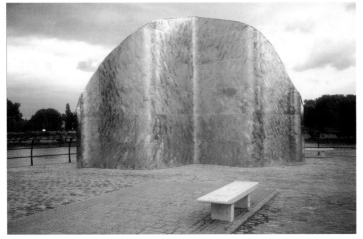

The artist Simon Packard began work on his steel sculpture 'Liquidity', beside the Thames at Ferry Quays in Brentford, in 2003 but it remained incomplete at the time of publication as residents complained it blocked the view of the river, was a health risk and encouraged antisocial behaviour. The work, which measures about 3 metres (10 feet) high by 5 metres (16 feet) long, was commissioned by the site's developers.

Turner Prize with works including the monolithic concrete cast *House* (1993) in Grove Road, Bow, but it was demolished by Tower Hamlets Council in early 1994. Tom Bloor's pop-art wallpaper in a Birmingham subway, part of a 2004 visual-arts event, was mistakenly torn down by council workers after less than twenty-four hours following complaints about flyposting, while in 2003 the artist Tracey Emin's proposed neon sculpture for her home town of Margate was rejected by its planning committee, who classified it as a shop sign. In Brentford *Liquidity* (2003), a competition-winning design by the artist Simon Packard at the Ferry Quays housing development, remained incomplete at the time of publication as residents complained that the 6 metres (20 feet) tall stainless-steel sculpture blocked their view of the river; the work has been threatened with demolition.

The stylised concrete figures of 'Shoulder to Shoulder' (2000) by the artist Ray Smith (born 1949) divide the road from the public space around Haymarket Metro station in Newcastle upon Tyne. At each end of the line of figures is a shallow basin, intended to collect the water that flows down from the steel elements of the sculpture.

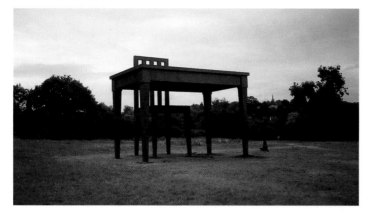

'The Writer' (Giancarlo Neri, 2003), a 9 metres (30 feet) high table with an empty chair, is seen here on London's Hampstead Heath, where it was on display during the summer of 2005; it is intended to refer to the loneliness of writing. The sculpture was made from steel with wood cladding and was first shown in Rome.

Even a lengthy consultation process does not ensure a positive public reception for an artwork, as Newcastle upon Tyne's *Shoulder to Shoulder* (Ray Smith, 2000) proves. This concrete water feature, sited in the north of the city at the Haymarket, was constructed in direct response to public requests for an artwork involving water but proved unpopular, although the space created by its installation has been successful.

Despite these occasional setbacks, public artworks in Britain and Ireland appear to be increasing in popularity, particularly those large or famous enough to be classed as tourist attractions. In the summer of 2005 a pair of very large-scale temporary artworks appeared in England – *The Writer* (Giancarlo Neri), a giant table and chair standing on Hampstead Heath, and *Another Place* (Antony Gormley), one hundred solid iron body forms partly buried along 3 km (2 miles) of Crosby beach, just north of Liverpool. Although both these works had already been shown elsewhere, they immediately became public attractions and received a significant amount of publicity. Before the *Angel of the North*, this would have been unlikely, but the twenty-first-century combination of art, regeneration and tourism seems set to produce yet more landmark structures as well as providing the right climate for the collaborative creation of smaller artworks.

A selective gazetteer of public artworks in Britain and Ireland

CHANNEL ISLANDS

JERSEY

Standing in St Helier's Liberation Square is the *Liberation Sculpture* (1995), a controversial and much-revised design by Philip Jackson that has become a well-known landmark. The monumental figurative bronze commemorates the liberation of Jersey in 1945 following five years of occupation by German forces.

Outside Jersey Airport, in the west of the island at St Peter, is the 5.5 metres (18 feet) high abstract geometric form *Helical Spire* (1997, glass and Jersey granite) by the sculptor Pauline Wittka-Jezewski.

ENGLAND

BEDFORDSHIRE

Dunstable

Outside the Asda supermarket on Vernon Place, in an area noted for Roman remains, is *Timelines* (Adrian Moakes, 2002, painted steel), nine welded steel plates forming an image of a Roman amphora 5 metres (16 feet) high. It is intended as a symbolic link between the modern town and its origins as a trading centre.

BERKSHIRE

Newbury

Beside Newbury Lock (near the canal bridge off Northbrook Street) is *Ebb and Flow* (2003) by Peter Randall-Page (born 1954), a granite bowl 2.4 metres (8 feet) in diameter set in a spiral granite path. An underground pipe connects lock and bowl, allowing the water in both to rise and fall simultaneously.

BUCKINGHAMSHIRE

Milton Keynes (see also page 9)

The city of Milton Keynes, mostly built during the 1970s and 1980s, has over fifty pieces of public art including the famous *Cows* (Liz Leyh, 1978, painted concrete), which graze north-west of the centre in North Loughton Valley Park, Bancroft. Many of the artworks are in the city centre, including *Octo* (Wendy Taylor, 1980, stainless steel), a figure-of-eight above a pool on the corner of Silbury Boulevard and Saxon Gate, and the jolly family group *Vox Pop* (John Clinch, 1988, bronze) in the middle of the shopping centre (page 1). The gritty, stylised group *O Wert Thou in the Cauld Blast* (Ronald Rae, 1984, granite) stands outside the central railway station. To the east in Campbell Park are several works dating from the 1990s, the most prominent being *Chain Reaction* (Ray Smith, 1992, painted steel), a column of red figures rising from low ground on the north side of the park.

CAMBRIDGESHIRE

Ely

Along the town's Eel Trail, which begins at the tourist information centre near the cathedral, are five artworks by Elizabeth-Jane Grosse dating from around 2002,

The form of 'Octo' (Wendy Taylor, 1980), a curling ribbon of stainless steel, is a variation of a Möbius strip, a single-sided surface formed by twisting a long rectangular strip through 180 degrees and joining its ends. It was commissioned specially for its site in Milton Keynes, where it stands above a pool and generates varying reflections in the water and the windows of the surrounding buildings.

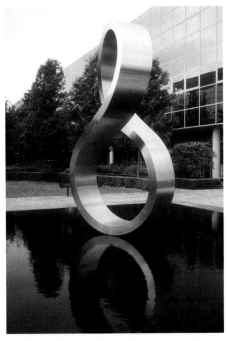

including a yellow eel mosaic in Jubilee Gardens, eight stainless-steel glavies (spears) mounted on the green outside the Maltings, and a woven willow eel hive in Cherry Hill Park; glavies and hives were used to catch eels. The hive takes the form of a tunnel 9 metres (30 feet) long and 2.5 metres (8 feet) high.

Peterborough

On display at Thorpe Meadows, off the A1179 about a mile west of the city centre in the Nene Park, are nineteen substantial works from the collection of the Peterborough Sculpture Trust, which was formed in 1978. These include the 3.5 metres (11 feet) high *Pyramid* (1981) by the sculptor John Maine (born 1942), comprising twenty-eight interlocking pieces of Portland stone.

CHESHIRE
Chester

The city's public-art trail begins in Town Hall Square and finishes out in the countryside, including over forty artworks, many of them small-scale. One of the largest is *Hush* (2002) in Weaver Street, where the sculptor Charles Poulsen has partly clad the topmost section of the façade of a former office block, now flats, in lead, on which the words 'hush' and 'house' are repeated; the work is 11 metres (36 feet) long.

CORNWALL
Penzance

Outside the railway station, east of the town centre, at the north end of Wharf Road, an attractive group of artworks (2003) marking the Penzance Passenger Transport Interchange includes a pair of oval bench seats with ceramic tops by Teena Gould, a pavement map of Cornwall in granite and marble, and twin steel sculptures cum signposts by David Kemp.

St Austell

The gardens of the Eden Project, located on the north-eastern edge of St Austell at Bodelva, feature works by a wide range of artists. Its education centre, The Core (opened 2005), is to house a huge sculpture of Cornish granite carved with spirals, by the artist Peter Randall-Page; it was being carved at the time of publication.

CUMBRIA
Hawkshead

To the south of Hawkshead are the remote hamlet of Grizedale and the Grizedale Forest Visitor Centre, which offers access to nearly one hundred artworks on forest walking and cycling trails. Grizedale Arts began working with artists producing sculpture in the landscape from 1977; northern England's extensive public-art programme followed the success of this initiative.

Above: *The black and white theme of the artworks installed outside Penzance railway station during a 2003 regeneration project reflects the colours of the Cornish flag of St Piran. The benches were made from white clay decorated with black and white glazes, while the paving, which includes a map of Cornwall, is of black granite and white marble.*

Left: *Grizedale Visitor Centre lies in the south of the Lake District, between Coniston Water and Windermere. Overlooking its car park is 'The Ancient Forester II' (David Kemp, 1995, wood); the original 'Ancient Forester' was made in 1982.*

Visible from a walking trail just east of Grizedale Visitor Centre is 'Stag Herd Roof' (Andy Frost, 1993, wood), topping a disused building. The name refers to the staggered (stag-herd) stance of the deer.

Whitehaven
 Whitehaven Development Company's Millennium improvements to the harbour area, completed in 2001, cost £11 million and included the installation of an array of maritime-themed artworks by a variety of artists (see page 24).

DERBYSHIRE
Chesterfield
 The town's art trail includes over forty works, the most impressive being *Poise* (Angela Conner, 2000) at 17 West Bars, just west of the central shopping area. This vertically set polished stone disk, 3 metres (10 feet) in diameter, is cut into six segments that sway independently, creating ever-changing shadows.

DEVON
Barnstaple (see page 16)

Great Torrington
 Several artworks were installed by the sustainable-transport charity Sustrans during 1999–2000 along the Tarka Trail, a cycling and walking route between Barnstaple and Okehampton. About 5 km (3 miles) south of Great Torrington, on the East Yarde section of the trail, are four site-specific ceramic seats designed by Katy Hallett, working with local schoolchildren. The looming, ferro-cement forms are clad in mosaic and are larger-than-life interpretations of characters from Henry Williamson's *Tarka the Otter*: *Bird Thrones*, *Bird Trio*, *The Guardian* and *White Tip and Greymuzzle*. Some of the mosaics were made from clay mined locally at Peters Marland quarry.

Hatherleigh (see page 22)

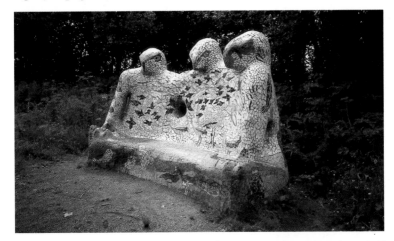

The 'Bird Trio' seat, one of four similar ceramic seats near East Yarde on Devon's Tarka Trail, was designed by Katy Hallett. Her one-tenth scale model was replicated at full scale in steel rods and steel mesh, then covered with mortar. Mosaics were added by Hallett in collaboration with children from Dolton School; around sixty children from three local schools were involved in making the seats, of which the most striking is the 4 metres (13 feet) high 'Guardian'.

There is an expansive view over Poole Harbour from the viewing platforms incorporated into 'Sea Music' (1991) by Anthony Caro (born 1924). The sculpture was refurbished in 2000.

DORSET
Poole

On the quayside in Poole's Old Town is *Sea Music* (Anthony Caro, 1991, steel), a massive abstract artwork cum viewpoint that includes viewing platforms at three levels. Caro, then a patron of Poole Arts Council, donated his working time to the project, whose entire material costs were privately sponsored.

DURHAM
Chester-le-Street

Just north of Chester-le-Street at Pelton Fell is one of three closely related

The head of 'King Coal' (David Kemp, 1992), on the C2C cycle route at Pelton Fell, was constructed using bricks from a demolished railway bridge; his crown was scrap metal from an old colliery. He is buried up to his neck in a large slag-heap.

Tony Cragg's 'Terris Novalis' (1997) stands in an exposed position on the edge of Consett, where the moorlands meet the industrial north-east. The work was commissioned by Sustrans and comprises giant versions of a theodolite and a level, both of which are around 5.5 metres (18 feet) in height.

sculptures on the C2C cycle route (see Consett): *King Coal* (David Kemp, 1992, recycled bricks, stone and steel) is a 15 metres (49 feet) high gaunt, crowned head resembling a giant chess piece.

Consett

Consett lies on the C2C cycle path connecting Sunderland and Whitehaven. On its route around the south-eastern edge of Consett, off the A692 near the Templetown roundabout, is *Terris Novalis* (Tony Cragg, 1997, stainless steel), two gigantic interpretations of Victorian surveying equipment mounted on representations of human and animal feet. About 6 km (4 miles) east on the C2C, off the A693 at East Castle, are *The Old Transformers* (David Kemp, 1990, recycled transformers and other metals), two 6 metres (20 feet) high human forms, the *Miner* and the *Ironmaster*, created from industrial waste; they look southward over a broad rural landscape (see page 25).

Darlington (see also page 11)

On the eastern outskirts of Darlington, at the north end of Morrison's shopping complex, Morton Park (junction of A66 and A67), is the landmark sculpture *Train* (David Mach, 1997, brick), which is 39 metres (128 feet) long and was built from nearly 182,000 bricks (see page 27). It stands close to the route of the original Stockton & Darlington Railway; bats may enter its interior via specially made bat bricks.

Gateshead

It is estimated that the *Angel of the North* (Antony Gormley, 1998, Cor-Ten steel, which oxidises naturally, giving a rusty appearance), sited on the southern edge of Gateshead, overlooking the junction of the A1 and A167, is seen by around 33 million people every year. Gateshead Council originated this landmark sculpture project in 1990 and Gormley was selected as the artist in 1994; he then worked with engineering consultants Ove Arup & Partners to realise the piece, which was given

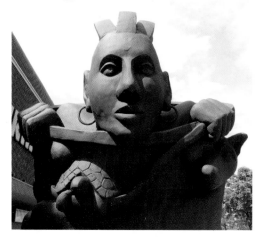

'Sports Day' (Mike Winstone, 1986), in the centre of Gateshead, was carved on site from a polystyrene block that was then covered in concrete and painted in bright colours; it was painted black in 1991. Winstone (born 1958) was Gateshead's sculptor-in-residence during 1985–6.

its title by the council. Initial local opposition to the project was followed by widespread support, and the *Angel* has become a tourist attraction (see page 5); access is from the northbound (west) side of the A167, a dual carriageway.

The first modern public artwork in Gateshead was *Nocturnal Landscape* (Keith Grant, 1983, terrazzo mosaic), one of three large mosaics sited at Gateshead Metro station as part of the Art in the Metro scheme. It is mounted on an interior wall of the ticket concourse, while Grant's mosaics *Night* and *Day* are located at platform level. Outside the station on West Street is the massive 4 metres (13 feet) high *Sports Day* (Mike Winstone, 1986, polystyrene covered by painted concrete), which was the first work to be made specifically for the Council's wide-ranging public-art programme.

Jarrow

In the centre of Jarrow at Viking Precinct is *The Jarrow March* (Graham Ibbeson, 2003, bronze), six larger-than-life figures commemorating the two hundred men who walked from Jarrow to London in 1936 to lobby Parliament for work. Another representation of the march can be seen at the town's Metro Station: Vincent Rea's *Jarrow March* (1984), made out of steel plate from a scrapped ship. The two stylised *Vikings* (1962) outside the shopping precinct are by Colin Davidson.

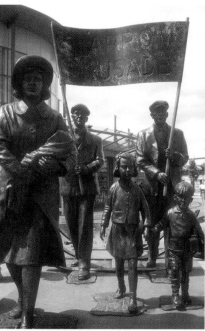

'The Jarrow March' (2003) by Graham Ibbeson (born 1951) stands outside Morrison's in the centre of Jarrow; the supermarket commissioned the sculpture.

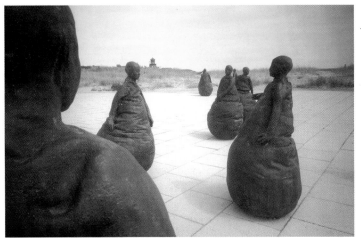

The twenty-two figures of 'Conversation Piece' by the Spanish sculptor Juan Muñoz (1953–2001) originated in 1996 as a fibreglass work located at the mouth of the river in Berwick-upon-Tweed. They were then cast in bronze and installed in late 1998 on the beach at South Shields.

Peterlee

The artist Victor Pasmore was appointed as consultant to the architects of Peterlee New Town in 1955. His *Apollo Pavilion* (late 1960s, reinforced concrete) in Oakerside Drive, Sunny Blunts, an abstract sculptural form bridging a lake, was intended as a focal point but rapidly became vandalised. The steps to its upper level were removed in the early 1980s and demolition was mooted, but the 25 metres (82 feet) wide structure is still extant (see page 9).

South Shields

The twenty-two humanoids of *Conversation Piece* (Juan Muñoz, 1998, bronze) stand on the edge of the beach (access from Harbour Drive) with a stunning view over the mouth of the Tyne. The roly-poly figures, each about 1.6 metres (5 feet) in height, are arranged in enigmatic groups.

Stockton-on-Tees

Dominating the exterior of Stockton's arts centre, the Arc in Dovecot Street, is Richard Wilson's *Over Easy* (1999), a slowly rotating disc 8 metres (26 feet) in diameter, which is partly glazed and partly yellow-rendered. The disc's movement refers to the performance arts taking place inside the Arc (see also page 21).

Sunderland (see page 8)

The rotating disk 'Over Easy', at the Arc in Stockton-on-Tees, appears to be an integral part of the building's façade but rocks alternately clockwise and anti-clockwise at about the speed of a minute hand on a clock. This almost indiscernible artwork cost a total of £205,000 and created many problems during its design, construction and installation, notably when the disk turned out to weigh more than expected, causing the initial motor drive to burn out.

Far left: *Ralph Brown's 'Meat Porters', in Harlow's Market Square, stands about 2 metres (7 feet) high on its plinth, but the two bronze figures, and the carcass that they carry – and into which they seem to merge – are slightly smaller than life-size. The Harlow Arts Trust, which commissioned the piece, aimed to place sculptures on sites where people congregated.*

Left: *Auguste Rodin's 'Eve' looks out over the rebuilt Harlow Water Gardens, with Elisabeth Frink's bronze 'Boar' in the water beyond. 'Eve' was first sited on Harlow's Broadway, then moved to the Water Gardens in 1966. The gardens originally comprised three parallel terraces into which were set canals, fountains and ponds.*

ESSEX
Braintree

In Great Notley Country Park, just west of the A131 on the south-western edge of Braintree, is the *Notley Bird* (Jonathan Clarke, 2001, cast aluminium). The kestrel has a wingspan of about 4.6 metres (15 feet) and with its plinth reaches 6 metres (20 feet) in height; it is sited on a hill off the A120, which passes to the north of the park.

Harlow

The planning of Harlow New Town began in 1946 and the Harlow Arts Trust was founded in 1953. The Trust built up a fine collection of public sculpture, much of which still remained in 2005, including *Meat Porters* (Ralph Brown, 1960, bronze) in Market Square, the earliest part of the centre to be completed. Several sculptures stood in the town's Water Gardens (1958–63), which were controversially demolished and rebuilt in 2002–4 as part of the award-winning Water Gardens retail and office development. Among other survivors from the original site are *Eve* (Auguste Rodin, bronze) and *Bronze Cross* (Henry Moore, bronze). See also page 76.

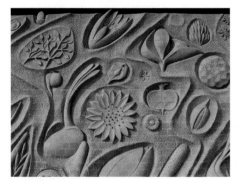

One of five carved brick reliefs depicting 'The Creation', each measuring nearly 2 metres (7 feet) high by 4 metres (13 feet) long, by Walter Ritchie at Bristol Eye Hospital. The panels were executed in 1983–6 by Ritchie, an artist who felt sculpture should be out 'in the street' rather than confined to art galleries.

Andrew Smith's 'Lollipop Be-bop' (2001) is one of twenty-four artworks at the Bristol Royal Hospital for Children. Young patients within the hospital are able to play with this giant toy by controlling its fibre-optic lighting.

Shellhaven (see page 12)

GLOUCESTERSHIRE
Bristol (see also pages 15 and 21)

Bristol's fine collection of post-1950 public art, mostly dating from the mid 1970s onward, includes *The Creation* (Walter Ritchie, 1986, Ibstock Red Marl brick), five

The 'Beetle' by Nicola Hicks stands outside Bristol's Wild-walk nature centre in Anchor Square; nearly 2 metres (7 feet) in length, its design is based on the rhinoceros beetle. It originally had long antennae but these, and their replacements, were broken, so screw-in substitutes are now installed when required.

On the west side of Bristol's tourist information centre in Anchor Square is a full-height ceramic map (2003) of the 'National Cycle Network' made by Marian Tucker, Sue Ford and Carol Arnold. It shows the major routes of the network, complete with several tiny cyclists, and is the second such map to be made by the three ceramicists; the first was originally sited in Birmingham's Centenary Square but was later moved to Belfast's quayside.

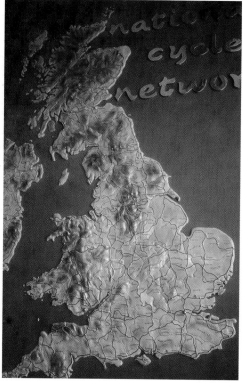

massive carved-brick reliefs on the façade of the Bristol Eye Hospital, Lower Maudlin Street (see page 16), and the nearby *Lollipop Be-bop* (Andrew Smith, 2001, stainless steel), a collection of giant, brightly lit lollipops outside the Bristol Royal Hospital for Children, Upper Maudlin Street. Several works stand in or near Anchor Square, notably the huge horned *Beetle* (Nicola Hicks, 2000, bronze) and the ceramic map of the *National Cycle Network* (Marian Tucker, Sue Ford and Carol Arnold, 2003).

Cinderford

The Forest of Dean Sculpture Trail, which includes around twenty artworks, begins and ends in the centre of the forest at Beechenhurst Lodge, close to Speech House Hotel and about 5 km (3 miles) west of Cinderford.

Gloucester (see page 13)

HAMPSHIRE
Basingstoke

Church Stone (Michael Pegler, 1994, granite), Wote Street, a hand-carved grey stone block almost 3 metres (10 feet) high, is the largest of the wide range of public artworks sited in Basingstoke's centre since 1989.

Chineham

On the A33 roundabout south of the village at the entrance to Chineham Business Park, Crockford Lane, is *Chineham Wave* (Ray Smith, 2000, painted steel), around one hundred red-painted figures that form a 'Mexican wave' and are designed to provide varied views.

Portsmouth

The 170 metres (558 feet) high *Spinnaker Tower* (Scott Wilson, 2005, concrete and steel) on Gunwharf Quays is the centrepiece of the redevelopment of Portsmouth's harbour. The landmark structure takes the form of an openwork billowing sail and includes three glazed viewing decks (see page 29).

Southampton

At the entrance to Hampshire's County Cricket Ground, the Rose Bowl, is *Howzat* (Richard Farrington, 2004, painted steel and aluminium), a 6 metres (20 feet) high set of cricket stumps with an equally large red ball removing a bail. The Rose Bowl is in West End, on the east side of Southampton, close to the B3035 and junction 7 of the M27.

Winchester (see page 33)

HEREFORDSHIRE

Stoke Lacy

A detailed, 4 metres (13 feet) high ceramic heritage map (2005) of Stoke Lacy by local potter Mark de la Torre can be seen on the exterior of the village hall.

HERTFORDSHIRE

Letchworth

Outside Letchworth Garden City's town hall on Gernon Road stands *Paradise Is* (Bettina Furnee, 2003, copper and steel), an openwork metal form in the shape of a house, which was designed to celebrate the centenary of the town – the first garden city – and the aspirations of its founder, Ebenezer Howard (1850–1928).

Stevenage

Stevenage was the first New Town to be designated, in 1946; its centre (1957–9) included the first pedestrian-only shopping area in England. The focal point of the Town Square is an openwork concrete clock tower designed by Leonard Vincent, one of the town centre's planners (see page 3). Nearby, on a raised platform, is *Joy Ride* (Franta Belsky, 1959, bronze), a mother carrying a child on her back; it

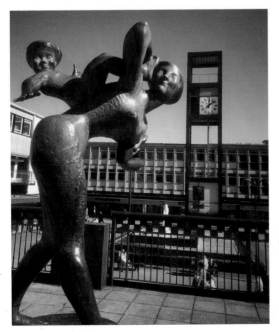

Franta Belsky's 'Joy Ride' (1959) looks out over Stevenage's Town Square, which is centred on a clock tower rising from a rectangular pool. The tower's frame is clad in black granite and bears a painted tile panel, about 1.5 metres (5 feet) square, showing a contour map of the area; the tiles were made by Carter's of Poole.

symbolised the younger generation in Stevenage. Overlooking the square is the former Co-op store (built 1958–9, Primark in 2005), whose façade is decorated with a jolly figurative tile mural designed by Hungarian-born artist Gyula Bajo of the CWS Architects' Department and intended to depict the activities of the local Co-op movement.

ISLE OF WIGHT
Cowes
The Boat Trail, a walking route linking East Cowes and Cowes via the chain ferry (or floating bridge) was unveiled in 2003. On the floating bridge section, lining the passenger walkway, is a series of wooden 'curiosity boxes' by furniture maker Fred Baier, in which local schools, clubs and invited artists have installed an intriguing variety of objects.

KENT
Folkestone
To mark the Millennium in Folkestone, Strange Cargo Arts Company made a plaster cast of one hand from each of 101 local people, each born in a different year of the twentieth century. The 'hands' were then cast in bronze and set on the 55 metres (180 feet) long wall approaching Folkestone Central Station, off Cheriton Road; the background, a wave of blue glass mosaic, was made by Theresa Smith of Mooch Design. *Like the Back of My Hand* was unveiled in 2004, having taken five years to complete.

Ramsgate
On the western edge of Ramsgate at Prince Edward's Promenade, West Cliff, stands *The Hands and Molecule* (2001) by the sculptor and potter David Barnes. The Millennium artwork, which includes a time capsule, comprises a pair of hands around 2.4 metres (8 feet) in height emerging from the ground and cradling an atomic structure.

LANCASHIRE
Blackpool
A series of artworks was installed on Blackpool's South Shore Promenade from 2001, following improvements to the sea defences. Known as the Great Promenade Show, they are intended to reflect different characteristics of the town and include the world's largest mirrorball, *They Shoot Horses, Don't They?* (Michael Trainor); it is 6 metres (20 feet) in diameter and is clad with almost 47,000 mirrors. Also notable are the small

Peter Freeman's 'Glam Rocks', three huge pebbles on Blackpool's South Shore Promenade, were inspired by Blackpool Illuminations and use hundreds of fibre-optic lights to produce changing colours. In the background is the giant mirrorball 'They Shoot Horses, Don't They?'.

Coast protection works at Blackpool around 2000 raised the height of the South Shore Promenade by 2 metres (7 feet), and many Victorian features were lost. Their replacements, known as the Great Promenade Show, included Peter Blake's 'Life is a Circus', two towers of tiny bronze circus performers.

figures of circus entertainers, *Life is a Circus* (Peter Blake, bronze), and the spiky abstract *Desire* (Chris Knight, Cor-Ten steel).

Burnley
The 122 metres (400 feet) long concrete mural sculpture (1973) by Charles Anderson stretching along the exterior of the town's sports centre, the Thompson Centre in Red Lion Street, shows outsize stylised figures running and jumping (see page 14).

Fleetwood (see page 24)

Liverpool
Above the main entrance of Lewis's store, on the corner of Ranelagh Street and Renshaw Street, is *Liverpool Resurgent* (Jacob Epstein, 1956, bronze), a 5.4 metres (18 feet) high naked male figure astride the prow of a ship; it was intended to represent the post-war regeneration of the city. To the east on Hope Street is Federation House (1965–6), its façade displaying a lengthy and complex concrete mural by William Mitchell.

Manchester (see also page 30)
Standing in front of the Bridgewater Hall on Barbirolli Square is *Touchstone* (Kan Yasuda, 1996, Carrara marble), a giant, smoothly rounded pebble. North-east of the city centre, outside the City of Manchester Stadium at the junction of Ashton New Road and Alan Turing Way, is the landmark sculpture *B of the Bang* (Thomas Heatherwick, 2005, weathering steel) (see page 29); its name is derived from the sprinter Linford Christie's description of an athlete starting a race.

The 'Messenger of Peace' (1986) stands just east of Manchester Town Hall, near the junction of Cooper Street and Lloyd Street The commission for this figurative bronze work, by the Manchester-born artist Barbara Pearson (1919–92), was awarded in a 1985 competition organised by the City Council to design a 'sculpture for peace'.

Morecambe

Morecambe's Tern project, which includes the improvement of sea defences, regeneration and the creation of a new image for the town, began in 1994. Its best-known artwork is the statue of the comedian *Eric Morecambe* (Graham Ibbeson, 1999, bronze), which stands on the Central Promenade above a flight of granite steps on which the famous Morecambe and Wise song 'Bring Me Sunshine' is engraved. Among the works on the Stone Jetty is a flock of bird bollards by David Kemp.

Salford

The Irwell Sculpture Trail runs for around 48 km (30 miles) from Salford Quays to the source of the Irwell on the South Pennine moors. One of its largest works is the 5 metres (16 feet) high mini-stadium *Arena* (Rita McBride, 2003, white ferro-cement) overlooking Littleton Road playing fields, Lower Kersal.

Wigan (see page 19)

LEICESTERSHIRE
Leicester (see below)

Loughborough

In the Market Place is *The Sock* (Shona Kinloch, 1998, bronze), a near-nude seated male figure with an outstretched left leg on which is a sock, symbolising the local hosiery industry. Despite a lengthy selection process and much public consultation, the design proved deeply controversial; however, the statue's strangely extended leg has become an object of some attraction.

LINCOLNSHIRE
Louth

The town's position on the Greenwich Meridian Line inspired several of the

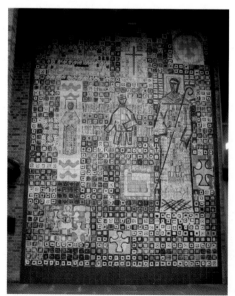

In the porch of St Aidan's Church (1957–9), New Parks Boulevard, New Parks, Leicester, is a large contemporary stoneware mural by William Gordon depicting scenes from the life of St Aidan. This was the first major tile commission obtained by Gordon, who produced studio pottery at the Walton Pottery in Chesterfield throughout the 1950s.

Outside Loughborough's Town Hall is 'The Sock' (1998), an almost 2 metres (7 feet) tall bronze by the Glasgow-born figurative sculptor Shona Kinloch (born 1962), who is well known for her gently humorous public artworks. 'The Sock' was cast in Edinburgh at the Powderhall Bronze Foundry.

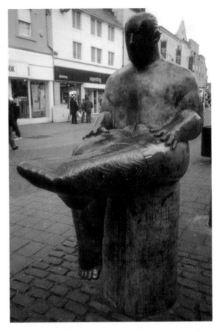

works in the Louth art trail, notably *Searching, Mapping* and *Solution* (2002), bronze and steel figures by Les Bicknell and Laurence Edwards that stand in the town centre. In Westgate Fields are four giant leaf sculptures (2002) in oak by Howard Bowcott, and Simon Percival's series *Navigation, Movement and Waterflow* (2001) can be found near the River Lud.

Whaplode
The best-known of the series of artworks commissioned for the village from the 1990s is the life-size bronze of a Vietnamese pot-bellied pig, the *Whapplehog* (Greg Lock, 1996, bronze), which stands on the main street.

LONDON
Barking and Dagenham
The *A13 Artscape* project (1997–2005) involved a series of artworks being installed along most of the length of the A13 road running through Barking and Dagenham, from the Movers Lane underpass in the west to the Goresbrook interchange in the east, where two of the most notable works are sited, the twin roundabout features known as *Scylla* and *Charybdis*. These tall, black, conical structures, made from concrete sprayed on to steel mesh, were designed by the Thomas Heatherwick Studios.

Camden
The piazza of the British Library, off Euston Road, St Pancras (see page 18), is dominated by the massive bowed figure of *Newton* (Eduardo Paolozzi, 1997, bronze); nearby, dotted round Poets' Circle, is *Planets* (Antony Gormley, 2002, granite), eight 1 tonne boulders incised with outlines of human bodies. Inside the Library is *Sitting on History* (Bill Woodrow, 1995, bronze), a seat in the form of a giant book.

Inside the spacious entrance hall of the British Library is Bill Woodrow's bronze book cum seat 'Sitting on History' (1995). Hanging on the hall's west wall is a huge and colourful tapestry woven by the Edinburgh Weavers to a design based on the 1975–6 painting 'If Not, Not' by the American artist R. B. Kitaj.

City of London

The Broadgate office development, which arose alongside Liverpool Street Station from 1986, included several large-scale abstract and figurative artworks chosen by the developers, Rosehaugh Stanhope (see page 17). The tallest, at around 17 metres (56 feet), is *Fulcrum* (Richard Serra, 1987, Cor-Ten steel), five planes of steel propped together in the Broadgate Octagon, while the vast, near-nude *Broadgate Venus* (Fernando Botero, 1989, bronze) occupies the east side of Exchange Square.

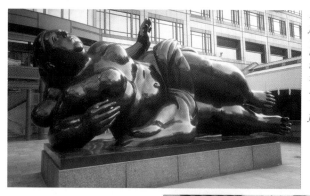

Fernando Botero's 4 metres (13 feet) high 'Broadgate Venus' (1989) is sited just above and beside a pool and water cascade installed in 1991 directly over railway tracks entering London's Liverpool Street Station. The 'Venus' was cast at the Mariani foundry near Carrara in Italy.

On the rear façade of 100 New Bridge Street, City of London (actually on Waithman Street), is a series of twenty-three large hand-made stoneware tile panels of 1992 by the potter Rupert Spira (born 1960), all with different and apparently three-dimensional patterns in a wide variety of glazes. The panels were commissioned by the block's developers, Rosehaugh Stanhope, who were also responsible for the Broadgate development.

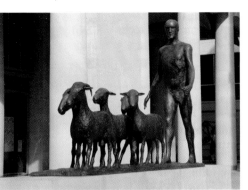

The bronze 'Paternoster' (1975), often referred to as 'Shepherd and Sheep', by Elisabeth Frink (1930–93) was commissioned for a site in Paternoster Square, London, at the heart of the 1960s offices immediately north of St Paul's Cathedral. In 1997 the work was moved to a site outside the Museum of London while the area was undergoing redevelopment; it was returned to the north side of Paternoster Square after building work was completed around 2003.

On the back of the office block at 100 New Bridge Street (actually in Waithman Street, approached from the main street by Pilgrim Street) are twenty-three large handmade stoneware tile panels (Rupert Spira, 1992), all with different optically confusing patterns in a wide range of colours.

Greenwich

The *Greenwich Mural* (Philippa Threlfall and Kennedy Collings, 1972), on a wall in Woolwich Road, was commissioned by the architects of Greenwich District Hospital, which was completed in the late 1970s but closed in 2001; however, the 18 metres (59 feet) long ceramic and stone mural was removed in late 2005 to make way for redevelopment and is to be relocated nearby (see page 13).

Hackney

The film studio where Sir Alfred Hitchcock began his career, Gainsborough Studios, New North Road, has been redeveloped as housing and offices. In its central square is a huge, enigmatic sculpture, unveiled in 2005 and entitled *Master of Suspense* (Antony Donaldson, 2003, Cor-Ten steel); it was made at the nearby Perseverance Works and stands on a broad, sloping plinth, also designed by Donaldson, which shelters more offices.

Occupying the centre of the Gainsborough Studios development of offices and flats in east London is a massive head of the film director Sir Alfred Hitchcock, who made his first black-and-white films at the former studios. The artist was Antony Donaldson, who wanted to portray Hitchcock as he was at thirty-eight years old, when he left for America; the bust faces towards Hollywood.

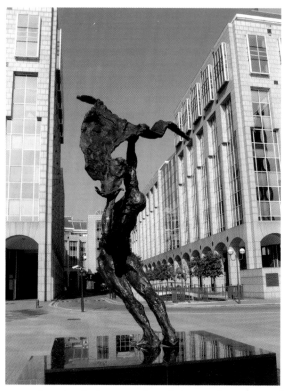

Artworks, all dating from 1992, around East India Dock include this symbolic bronze entitled 'Renaissance' (Maurice Blik) at the water's edge, the nearby granite blocks of 'Meridian Metaphor' (David Jacobson), salvaged from the old dock pier, and the bright yellow cut-out dockers of 'Shadow Play' (Dave King, steel and bronze) outside the offices in Clove Crescent.

several water features and sculptures, the most striking being *Renaissance* (Maurice Blik, 1992, bronze), by the station entrance.

Westminster

Forming part of the façade of the former Time-Life Building, 153–7 New Bond Street, is a stone screen (Henry Moore, 1953) of four huge abstract figures. In Adelaide Street, just north of the Strand, is the memorial *A Conversation with Oscar Wilde* (Maggi Hambling, 1998, bronze and granite), which depicts the writer rising from his sarcophagus.

NORFOLK
Cromer

Inlaid into the promenade at the shore end of the Pier is a compass-like installation in granite (David Ward and Shaun Ruffles, 2005) that celebrates the town's historic lifeboat missions. Cut into the granite are details of the rescues in a specially developed font designed by Ray Carpenter.

NORTHAMPTONSHIRE
Corby

The original *Spirit of Corby* was a large-scale abstract steel, limestone and water installation unveiled in the town's Queen's Square in 1974. It marked the twenty-fifth anniversary of Corby becoming a New Town, and its form, including a vertical steel spiral about 9 metres (30 feet) in height, referred to the steelmaking process.

Redevelopment of the town centre in 1988 resulted in the dismantling of the sculpture; the spiral section was moved to a roundabout, where it stood until storm damage in 1997 led to proposals to scrap what remained of the work. However, a grant was obtained from the Heritage Lottery Fund to restore the *Spirit of Corby*, which was erected in New Post Office Square in 2004.

NORTHUMBERLAND
Longbenton (see page 25)

Newcastle upon Tyne (see also pages 22, 31 and 34)
 Newcastle's lavish Civic Centre (1960–8) at Barras Bridge displays a huge variety of artworks including, on and around its exterior, the *River God Tyne* fountain (see page 10) and *Swans in Flight*, both by David Wynne (born 1926), and movable metal screens by Charles Sansbury. Glass screens to the entrance hall carry historical engravings by John Hutton, and inside the banqueting hall are cast-aluminium grilles by Sansbury and a tapestry by John Piper, while a full-height abstract glass mural (1963) by Victor Pasmore can be found in the former rates hall.

Below left: *A small section of the glass screen enclosing the Grand Stair Hall (visible within) at Newcastle upon Tyne's Civic Centre; the glass engravings, by the New Zealand-born artist John Hutton (1906–78), depict images from local history. Hutton also designed the west window of Coventry Cathedral, completed in 1962.*

Below right: *Outside Newcastle upon Tyne's Laing Gallery in John Dobson Street is the 'Blue Carpet', an outdoor public square floored with 22,500 purpose-made tiles made from white resin and recycled glass shards; it was created by the artist Thomas Heatherwick.*

Above left: *Eduardo Paolozzi's 7 metres (23 feet) high monumental bronze 'Vulcan' (2000) was commissioned by Parabola Estates as a landmark sculpture for their redevelopment of a 1930s GPO sorting office, now known as Central Square, located behind the railway station in Newcastle upon Tyne.*

Above right: *Sited close to Paolozzi's 'Vulcan' in Newcastle is 'Reaching for the Stars' (2002) by the well-known Leeds-born sculptor Kenneth Armitage (1916–2002); nearly three storeys in height, this was also commissioned by Parabola Estates.*

Of the wide range of more modern public artwork in Newcastle, one of the most intriguing pieces is in the city centre on John Dobson Street: *Blue Carpet* (Thomas Heatherwick, 2001, tiles made from resin and glass) is the shiny blue paved square in front of the Laing Art Gallery. There are cheeky glimpses beneath the 'carpet' where it rolls up to form benches, and at its east end is the spiral *Blue Carpet Staircase* (cedar and plywood). Just to the north in Northumberland Road is the pair of murals *Newcastle through the Ages* (Henry and Joyce Collins, 1974, *ciment fondu*), showing local buildings, people and historical events in low relief (see page 13).

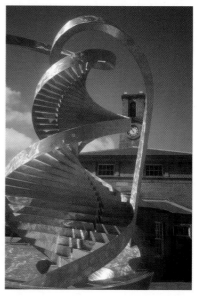

The 4.5 metres (15 feet) high galvanised steel 'DNA Spiral' (2000) is a work by the American designer and architectural critic Charles Jencks (born 1939). It refers to the DNA double helix and stands outside Newcastle upon Tyne's Centre for Life, a life sciences research centre.

On the north bank of the River Tyne at Royal Quays Marina,
North Shields, is the huge, tripod-like 'Tyne Anew' (1999).
Just inland, in the middle of the Royal Quays shopping centre,
is the 'Lightning Clock' (2001) by Andy Plant (born 1955), a
mechanical sculpture over 9 metres (30 feet) high; it performs
hourly, using sound, wind and smoke effects.

Well south in Central Square, just south of
Newcastle railway station, is the massive machine-
like humanoid form of *Vulcan* (Eduardo Paolozzi,
2000, bronze); Vulcan was the god of fire, the
blacksmith of the Roman gods. The piece is sited
close to the former locomotive workshop of Robert
Stephenson. Just off the square, between two office
blocks, is *Reaching for the Stars* (Kenneth Armitage,
2002, coloured bronze), an outsize outstretched
arm protruding from the ground. Nearby, west of
the station in Times Square, is the *DNA Spiral*
(Charles Jencks, 2000, galvanised steel), standing
in front of the Centre for Life, which commissioned
the work.

North Shields

Overlooking the entrance to the Royal Quays Marina, at the river end of Coble
Dene, is the crane-like abstract sculpture *Tyne Anew* (Mark di Suvero, 1999, painted
steel), the prolific New York-based artist's first British commission. At about 21
metres (69 feet) in height, it is a metre (3 feet) taller than the *Angel of the North* and
is painted in specially made Redwood Orange paint to withstand the weather. Just
to the south, at the International Ferry Terminal, Royal Quays, is *Dudes* (Permindar
Kaur, 2002, cast steel), a small army of brightly coloured invading figures marching
down a small hill at the edge of the car park.

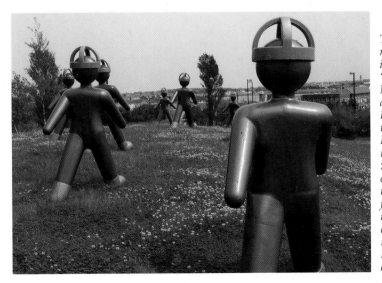

Thirteen 1.7
metres (5 feet 7
inches) high
'Dudes', by
Nottingham-born
artist Permindar
Kaur, approach
the International
Ferry Terminal on
the Tyne at North
Shields. Two more
of the figures are
inside, while a
further three were
installed at
destination
terminals in
Bergen, Ijmuiden
and Gothenburg.

On the Milton Street side of Nottingham's Victoria Centre, behind the bicycle racks, is 'Cycle', a ceramic tile mural showing computer-manipulated images of moving bicycles; it was designed and made by the London artist Robert Dawson.

NOTTINGHAMSHIRE
Nottingham
In the central shopping area, behind the bicycle park on the Milton Street side of the Victoria Centre, is the dramatic mural *Cycle* (Robert Dawson, 2001, printed tiles). It is almost 15 metres (49 feet) long and about 2.4 metres (8 feet) in height and shows convincing computer-manipulated images of moving bicycles. To the west, in the forecourt of the Nottingham Playhouse, Wellington Circus, stands *Sky Mirror* (Anish Kapoor, 2001, polished stainless steel), an almost upright concave mirror nearly 6 metres (20 feet) in diameter; it cost £1,250,000 and is intended to reflect the ever-changing surroundings (see page 28).

OXFORDSHIRE
Abingdon
Two early-twenty-first-century residential and mixed-use developments in the centre of Abingdon have included substantial artworks. On the former brewery site, off Ock Street, is a sculpture (2003) by the Bristol-based artist Walter Jack comprising seven iron 'planks' rising 4 metres (13 feet) from the ground in a curved, barrel-like form. In the courtyard of Neave Mews is the 3.5 metre (11 foot) high *Abingdon A* (Philip Bews and Diane Gorvin, 2005), a giant Portland stone letter 'A' within a seating area.

Thame
Thirty artworks stand by the Phoenix Trail, a part of the National Cycle Network linking Thame with Princes Risborough along the route of a disused railway. They include *Winged Seat* by Angus Ross, inspired by the red kites often seen overhead in this area.

RUTLAND
Empingham
On the north shore of Rutland Water at the Sykes Lane picnic area (just south-west of Empingham, off the A606) is *The Great Tower* (Alexander, 1980, bronze). The sail-like 9.3 metres (31 feet) high work was one of the largest modern-day bronzes to be cast at the Morris Singer foundry at Basingstoke; the London-born artist, Alexander, preferred to be known by his surname alone.

'Leaning' is one of a series of works by the sculptor Rick Kirby (born 1952) at the Port Marine development in Portishead. Exploring the same theme – two figures reaching out to touch each other – is Kirby's better-known 'Cross the Divide' (2000), which stands outside the main entrance to St Thomas's Hospital off London's Lambeth Palace Road.

SHROPSHIRE
Telford (see page 19)

Over 2000 square metres (22,000 square feet) of a retaining wall beside the road at Nabb Hill was faced with bands of coloured tiles resembling geological strata during its construction in 1982–3; the project designer was Kenneth Budd for the Telford Development Corporation.

SOMERSET
Bridgwater

The first *Willow Man*, a 12 metres (39 feet) high running figure made from willow woven on to a steel frame, was created by Serena de la Hey near Bridgwater in September 2000. The work, the largest willow sculpture in the United Kingdom, was destroyed by arsonists in May 2001 but recreated by the artist as *Willow Man II* in October 2001. The figure, known locally as the 'Angel of the South', stands beside the northbound side of the M5 between junctions 23 and 24.

Clevedon (see page 30)

Portishead

The best-known work in the Port Marine development's award-winning public-art programme is *The Angels of Portishead* (Rick Kirby, 2002, mild steel), five female figures, about 5 metres (16 feet) in height, overlooking Central Park; they refer to the town's five Second World War radio masts (see front cover). All the works have strong connections with the town's history and include a maritime-themed wall relief by Michael Disley, *Boundaries* (fencing by Michael Fedden), *Crouch* and *Leaning* by Rick Kirby, and the monumental *Towards the Sky* (Ann Christopher, 2002, Cor-Ten steel).

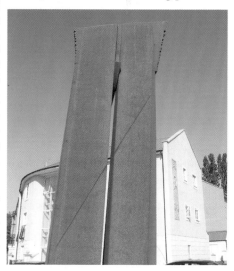

The 6 metres (20 feet) high abstract piece 'Towards the Sky' by the Bath-based sculptor Ann Christopher (born 1947) occupies a central place in Portishead's Port Marine development. In the background, on the gable end, is a jaunty wall relief by the sculptor Michael Disley (born 1962).

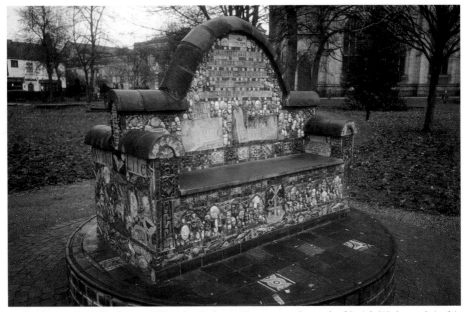

In the churchyard of St Peter ad Vincula, Stoke-on-Trent, near the tomb of Josiah Wedgwood, is this ceramic bench marking the Queen's Jubilee in 2000. Its design, by artists Helen Sayer, Philip Hardaker and Edgar Ruddock, features local images, including the footballer Stanley Matthews.

Weston-super-Mare

Travelling Light (Peter Freeman, 2004, stainless steel) is a light sculpture sited on a 15 metres (49 feet) high mound at junction 21 of the M5. The 13 metres (43 feet) high column includes two thousand digital lights programmed to change colour daily; at a total height of 28 metres (92 feet) it is visible for miles around and is intended to mark the gateway to the south-west.

STAFFORDSHIRE
Stoke-on-Trent

Ceramic public artworks in Stoke-on-Trent include a celebratory Jubilee bench (2000) in the churchyard of St Peter ad Vincula, Glebe Street, Stoke; colourful pictorial murals (1994) by Elizabeth Kayley at either end of the subway at Stoke-on-Trent railway station; and the brick and terracotta frieze (Frank Maurier, 1980) on the façade of the Potteries Museum and Art Gallery, Bethesda Street, which depicts work in the pottery industry. See also *The Spirit of Fire* on Lewis's store in Hanley (see page 10).

Wolverhampton

Wolverhampton Science Park lies about 2 km (1.2 miles) north of the city centre, just off the Stafford Road (A449). Its major artwork is *Aspire* (2004), by Philip Bews (born 1951) and Diane Gorvin (born 1956), a 5 metres (16 feet) tall stainless-steel spire set above a pool in which is a steel spiral form.

SUFFOLK
Aldeburgh

Sited at the north end of the beach is *Scallop* (Maggi Hambling, 2003, stainless

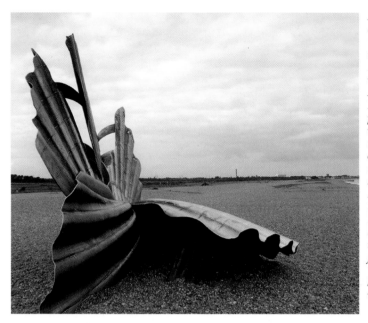

Maggi Hambling's controversial 'Scallop', a monument to Benjamin Britten, was installed on Aldeburgh beach in November 2003 but proved unpopular with some local residents as it obscured the view of the sea. The steel shell was made by Hambling (born 1945) with Sam and Dennis Pegg at their local foundry; cut into its rim is a line from Britten's opera 'Peter Grimes': 'I hear those voices that will not be drowned'.

steel), a huge scallop shell over 4 metres (13 feet) in height, which is a tribute to the composer Benjamin Britten.

Lowestoft

Marking the most easterly point in Britain, Lowestoft's bleak Ness Point, is the *Euroscope*, a flat, circular direction indicator or toposcope installed around 2000. The metal and concrete platform shows the distance to major British and European cities and landmarks. On the sea wall behind the toposcope is a 12 metres (39 feet) high water outfall tower, built during 1999–2001 and transformed into the *Ness Beacon* by the artist Chris Tipping using a spiralling glass canopy; however, this has

At Lowestoft's Ness Point is the 'Euroscope', a ground-level direction indicator that bears the distance in miles to major European capitals and other landmarks, including Land's End. The well-known bronze figure of a fisherman, 'Call of the Sea' (William Redgrave, 1980), stood in the resort's Station Square until removed in 2004 to facilitate improvement works but it is to be re-erected on the South Pier.

suffered badly from vandalism. These works were joined, and somewhat overwhelmed, in late 2004 by the tallest wind turbine in the United Kingdom, at 126 metres (413 feet).

SURREY
Kingston upon Thames (see page 18)

Woking
In the centre of Woking, in Crown Passage, just north of the railway station, stands *The Martian* (Michael Condron, 1998, mirror-polished stainless steel), a 7 metres (23 feet) high tripod-like representation of a Martian fighting machine as described by H. G. Wells in *The War of the Worlds* (1898), written while the author was living in Woking.

SUSSEX, EAST
Hastings
Spanning part of the Alexandra Park boating lake is *Continuum* (Rick Kirby, 2005), a continuous arc of stainless-steel figures rising about 3.5 metres (11 feet) above the surface of the water.

SUSSEX, WEST
Cocking
Beginning on the South Downs Way just south of Cocking is the Chalk Stones Trail, an 8 km (5 mile) walk taking in thirteen *Chalk Stones* (2002), each about 2 metres (6 feet 6 inches) in diameter, made by the environmental artist Andy Goldsworthy out of chalk taken from a local quarry. The trail makes a westward loop across downland, ending in West Dean. *The Cocking History Column* (2005) depicts scenes from the village's history (see page 31).

Goodwood
Around sixty of the Cass Sculpture Foundation's large-scale commissioned works are on display at its Sculpture Park in Goodwood, about 8 km (5 miles) north of Chichester. Telephone 01243 538449 for details of opening times and admission charges.

Horsham
In West Street is *The Rising Universe* (Angela Conner, 1996, bronze), a sculptural fountain in the form of a massive rising and falling bronze sphere. It commemorates the poet Percy Bysshe Shelley, who was born in Horsham; its design was inspired by Shelley's poem 'Mont Blanc'.

At the top of the cascade in Birmingham's Victoria Square is the monumental female form of 'The River' by the sculptor Dhruva Mistry (born 1957); below, within a second pool, is Mistry's 'Youth', a group comprising kneeling figures of a boy and a girl with a triple-bowled fountain.

WARWICKSHIRE
Birmingham

The upper level of the cascade in Victoria Square, in front of the Council House, is centred on a sculptural fountain, *The River* (Dhruva Mistry, 1993, bronze); other works by Mistry form part of the water feature at lower levels. Opposite is *Iron:Man* (Antony Gormley, 1992, iron), a rust-coloured, leaning torso 6 metres (20 feet) high whose legs are speared into the pavement. Just west is another major public space, Centenary Square, in which the colourful and controversial *Forward* (Raymond Mason, 1991, polyester resin), a group of traditional down-to-earth figures, stood until 2003, when it was badly damaged by fire and subsequently removed. Still in the square is the allegorical semi-abstract fountain *Spirit of Enterprise* (Tom Lomax, 1991, bronze), which attempted to represent the modern city. There are several artworks to the east in the redeveloped Bullring, notably the twice-life-size *Bronze Bull* (Laurence Broderick, 2003, bronze), which stands at the main entrance to the shopping centre, off Rotunda Square. The 2.2 metre (7 foot) high animal is modelled on a Hereford bull.

On the north-eastern edge of Birmingham at Castle Vale is the landmark Spitfire sculpture *Sentinel* (Tim Tolkien, 2000, steel); it stands on a roundabout at the intersection of Chester Road and Tangmere Drive, just north of junction 5 of the M6, adjacent to the former Castle Bromwich Aeroplane Factory. The sculpture's three Spitfires rise 16.5 metres (54 feet) from the ground, leaving steel 'trails' a total of 200 metres (219 yards) in length.

Coventry

At the Lidice Place entrance to the Lower Precinct, in the city's main shopping area, is the *Cullen Mural* (Gordon Cullen, 1958, tube-lined and screen-printed tiles), a colourful pictorial tile mural showing images relating to Coventry from prehistoric times up to the 1950s; it was originally sited on the ramp entrance to the Lower Precinct but was restored and relocated in 2002. At the southern edge of the Precinct in Bull Yard is the Three Tuns public house, whose complete 12 metres (39 feet) long frontage is taken up by a rugged, highly textured, abstract concrete mural (William Mitchell, 1966) with a vaguely industrial theme.

On the north-east fringe of the city centre is Millennium Place (opened 2003), which

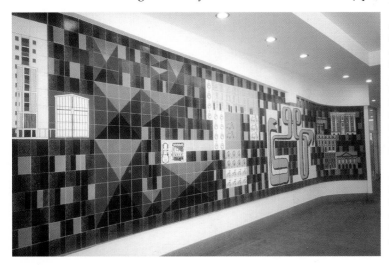

All the imagery of the 'Cullen Mural' (1958), in Coventry's Lower Precinct, relates to the city's history and includes references to ribbon making, watchmaking, the cycle industry and car manufacture, as well as depictions of dinosaurs, Georgian architecture and tower blocks.

is crossed by the twin tubes of the *Whittle Arch*, a landmark structure designed by architects MacCormac Jamieson Prichard; the arches span about 60 metres (197 feet) and are clad in perforated stainless steel. Other artworks, notably *Public Bench* (Jochen Gerz, 2004, acrylic), were installed in and around Millennium Place as part of the Coventry Phoenix Initiative, a regeneration plan that began in the early 1990s.

Three miles north of the city centre is Rowley's Green, where about 2.4 km (1.5 miles) of the walls of the dual carriageway Phoenix Way were faced in 1997 with over 1.5 million bricks to a design by Derek Fisher; their colours and patterns stem from Coventry's history and have a vertical emphasis in order to be seen clearly from passing vehicles.

WILTSHIRE
Swindon
In Croft Woodlands, a country park on the southern edge of Swindon (off the B4006), is the strange *Wish Hounds* (Lou Hamilton, 1993), which was inspired by local legends. Three hounds, high above the ground, pursue each other at the end of an avenue of lime trees.

WORCESTERSHIRE
Redditch
Inside the Kingfisher Shopping Centre, located in the centre of Redditch next to the railway station, is a series of twelve large-scale mosaic murals by Eduardo Paolozzi; they depict the history of Redditch and were installed in 1983.

YORKSHIRE, EAST
Bridlington
Bridlington's South Promenade Improvement Scheme, completed in 1998, included the *Nautical Mile*, a terrazzo pavement sculpture around 1.9 km (1.2 miles) in length, with inset text by Mel Gooding reflecting the town's history and natural history. The pink terrazzo slabs were manufactured by Pallam Precast.

YORKSHIRE, NORTH
Middlesbrough
In the town's Central Gardens, and over 9 metres (30 feet) high, is *Bottle of Notes* (Claes Oldenburg and Coosje van Bruggen, 1993, painted steel), an openwork structure of steel 'handwriting' in the shape of a near-upright giant bottle; the work is a tribute to Captain Cook. Just north, in Corporation Street, is *Spectra-txt* (Peter Freeman, 2005, mirrored stainless steel), a 10 metres (33 feet) high column set

The text of Mel Gooding's 'Nautical Mile', which runs along the terrazzo paving of Bridlington's South Promenade, features references to local events and people, including the fisherman and lifeboat man Kit Brown, drowned during an attempted rescue in 1898.

Above left: *The idea of a landmark public sculpture in Middlesbrough originated in 1986, but construction of 'Bottle of Notes' proved difficult, requiring two roughly half-scale models to be made before the work was finally completed by steel fabricators at Hebburn, near Gateshead; the sculpture was installed in Middlesbrough's Central Gardens in September 1993.*

Above right: *Peter Freeman's interactive column 'Spectra-txt', in Middlesbrough's main shopping area, changes colour in response to text messages; texting 'boro' turns it red, the colour worn by the local football team.*

Below: *Redcar's contribution to the growing amount of humorous, animal-themed street sculpture is the group of nine steel penguins seen viewing the Esplanade railings, which display a series of wrought-iron 'seaside postcards'. More entertaining animals can be found in Bolton, where four concrete elephants (whose history is unknown) stroll across the Newport Street precinct.*

The sculptor Richard Farrington (born 1956) made the original of 'The Circle', the giant charm bracelet that stands on the cliffs near Saltburn, in 1990 at the nearby British Steel rolling mill in Skinningrove. He made a second version in 1996 after the first had been vandalised and lost in the sea; only the figure of the Cleveland Bay Horse was recovered.

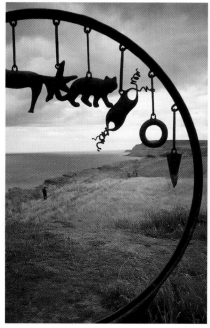

with fibre-optic lights that change colour in response to text messages.

Redcar

The artist-blacksmith Chris Topp won a design competition for Redcar's promenade railings with the concept of a series of colourful seaside postcard panels in wrought iron; twenty-three panels were installed along 230 metres (252 yards) of the promenade at the west end of the Esplanade during 1994–5. A little further west along the seafront at Newcomen Terrace is a group of nine somewhat bemused steel penguins (Tony Wilks, 1994), each about a metre (3 feet) high.

Saltburn

On the Cleveland Way long-distance footpath about 1.5 km (1 mile) east of Saltburn at Hunt Cliff are three steel sculptures (1990) by Richard Farrington: *Trawl Door*, *The Circle* and *Pillar*. Best known is *The Circle*, a charm bracelet over 2 metres (7 feet) in diameter, which was broken and rolled into the sea by vandals in 1996; it has since been replaced by a replica, also by Farrington.

YORKSHIRE, SOUTH
Sheffield

Sheffield's Peace Gardens, off Pinstone Street just south of the town hall, were

Beside Sheffield's Town Hall in Pinstone Street are the Peace Gardens (1997–8). The circular gardens centre on a fountain, towards which water flows from huge bronze vessels down eight cascades and along channels lined with leaf-like ceramics, the 'Aquatic Plantforms' by Tracey Heyes (born 1964); these depict the plant life that has returned to local rivers after years of industrial pollution.

completely rebuilt during 1997–8 and centre on the circular, eighty-nine-jet Goodwin Fountain. Surrounding it is a series of giant bronze vessels (metalwork by Brian Asquith) from which water flows down tiled cascades and into long rills (ceramic work by Tracey Heyes); the water vessels stand on sandstone bases carved by Richard Perry. All the decorative forms relate to the city's flora, rivers and industry. In Burgess Street, immediately west of the Peace Gardens, is a high-relief abstract concrete mural (William Mitchell, 1972), about 12 metres (39 feet) long by 2 metres (7 feet) high, which now forms the first-floor façade of Somerfield (see page 12).

YORKSHIRE, WEST
Bradford (see also page 15)
The lightly amusing *Grandad's Clock and Chair* (Timothy Shutter, 1991, sandstone) stands against a wall on Chapel Street, Little Germany. The stone armchair and clock refer to the contents of a mill owner's office.

Huddersfield
At the request of his wife, Lady Wilson, the statue of *Harold Wilson* (Ian Walters, 1999, bronze) in St George's Square, in front of the railway station, shows the former prime minister without his trademark pipe. To the south is Queensgate Market (1969–70), whose east façade, facing the inner ring-road on Queensgate, is decorated with a series of massive ceramic murals entitled *Articulation in Movement* by the German-born sculptor Fritz Steller (born 1941). The work, which was made from Stourbridge fireclay, has nine large panels and a free-standing 10 metres (33 feet) high sculpture pierced by a staircase to the market; the abstract design reflects the structure and use of the market hall (see page 14).

Outside Huddersfield's railway station is the one-and-a-half times life-size statue of 'Harold Wilson' (1999) by the sculptor Ian Walters; the bronze figure was cast at the Morris Singer foundry. Harold Wilson was born in Huddersfield and was prime minister during 1964–70 and 1974–6.

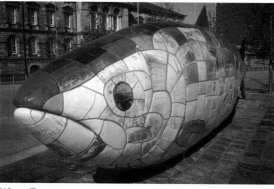

Belfast's 'Big Fish' (John Kindness, 1999), a giant blue-and-white ceramic tiled 'salmon' on Donegall Quay, was commissioned to celebrate the regeneration of the rivers Lagan and Farset, after which Belfast is named. Its surface displays texts and images related to the city's history.

West Bretton

The Yorkshire Sculpture Park displays an international collection of open-air sculpture in its landscaped grounds at West Bretton, near Wakefield. Telephone 01924 832631 for details of opening times.

NORTHERN IRELAND

Belfast (see also page 23)

On the façade of Transport House (1956–9), High Street, the Belfast headquarters of the Amalgamated Transport and General Workers' Union, is a dramatic five-storey-high tile mural set on a slightly concave wall (see page 7). It depicts heroic workers in local industries, including aircraft manufacture and shipbuilding, and was made by Carter's of Poole in Dorset. Just to the east on Donegall Quay is the *Big Fish* (John Kindness, 1999, screen-printed blue-and-white ceramic tiles), a 10 metres (33 feet) long installation in the shape of a salmon covered with images relating to the history of Belfast. Another ceramic work by Kindness, the *Waterfall of Souvenirs* (1991), stands in the Europa Bus Station, Glengall Street.

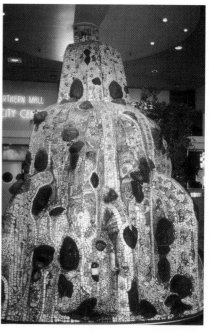

Slightly south of the *Big Fish*, on Hanover Quay, is a ceramic map of the *National Cycle Network* (Marian Tucker, Sue Ford and Carol Arnold, 2001), the first such map to be commissioned by Sustrans; a second is sited in Bristol, where the cycling charity has its headquarters. The map consists of 156 ceramic tiles fitted together like a jigsaw.

Derry

Outside Derry City Council's headquarters on Strand Road, beside the River Foyle, is *Atlantic Drift* (Locky Morris, 1998, wood),

The 5 metres (16 feet) high ceramic 'Waterfall of Souvenirs' (John Kindness, 1991) stands in Belfast's Europa Bus Station on Glengall Street. It was commissioned to mark the opening of the bus station in 1989, and its cascade of souvenirs aims to remind visitors of the places that can be reached by Ulsterbus services.

Up to about 4 metres (13 feet) above ground level, the stainless-steel surface of the landmark 'Dublin Spire' is polished in an abstract design to provide a good reflective surface. The tip of the monument can sway up to a maximum of 2.5 metres (8 feet).

made up of huge timber piles salvaged from a nearby old jetty. The piles were set vertically in totem-like formations and reach a height of 10.4 metres (34 feet).

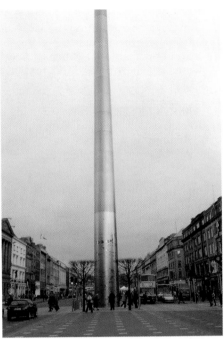

REPUBLIC OF IRELAND
Dublin
The *Dublin Spire* (Ian Ritchie Architects, 2003, stainless steel), a landmark sculpture in the centre of O'Connell Street, is 120 metres (394 feet) high and is by far the tallest structure in the city centre. It measures 3 metres (10 feet) across its base and tapers to a 15 cm (6 inches) wide beacon at the top.

West of the city centre on the Nangor Road, near the junction of the M50 and the N7, is Park West business park and a rare feast of public artwork on a grand scale. The most dramatic is *Wave* by Angela Conner, a 37 metres (121 feet) high snaking spiral of carbon fibre on a steel frame; when erected in 2001 it was the tallest sculpture in Europe. Its tip can sway up to 6 metres (20 feet) in the wind. Other Park West works by Conner are a version of *Poise* (see Chesterfield, Derbyshire) and *Rolling Stones*, two massive, rolling spheres. Also particularly notable are the cascade and figures comprising *The Bastard Son of Sisyphus* (Orla de Bri, 1999) and a series of large-scale wall hangings in office lobbies.

ISLE OF MAN
Ballasalla
Outside Ronaldsway airport in the Isle of Man is the *Three Legs of Mann* by the Manx sculptor Bryan Kneale.

Douglas
A modern figurative bronze of *Norman Wisdom* by the Isle of Man artist Amanda Barton (born 1964) sits on a bench outside

In front of the entrance to Ronaldsway airport stands the 'Three Legs of Mann' (1979, bronze), an interpretation of the traditional symbol of the island, by the Manx sculptor Bryan Kneale (born 1930).

the Town Hall on Ridgeway Street. Barton's banjo-playing bronze of *George Formby* leans on a nearby lamp-post at the corner of Ridgeway Street and Lord Street. There are many other artworks on the island, including the Royal National Lifeboat Institution memorial (Michael Sandle, 2002, bronze) on the Loch Promenade in Douglas, where the world's first lifeboat service was established.

SCOTLAND

ABERDEENSHIRE
Kemnay

Kemnay is about 23 km (14 miles) north-west of Aberdeen. Overlooking the nearby Kemnay granite quarry is *Place of Origin*, a huge granite hill at the quarry's summit; it was created during 1999–2003 by artists John Maine, Brad Goldberg and Glen Onwin as part of a landscape project that celebrated the 150th anniversary of the quarry.

DUNDEE

In the High Street is a 2.4 metres (8 feet) high statue of *Desperate Dan* (Tony and Susie Morrow, 2001, bronze), a famous comic character from the *Dandy*, published in Dundee by D. C. Thomson & Company. Dan's dog Dawg also forms part of the work.

EDINBURGH

The monumental fragmented figure *Wealth of Nations* (Eduardo Paolozzi, 1993,

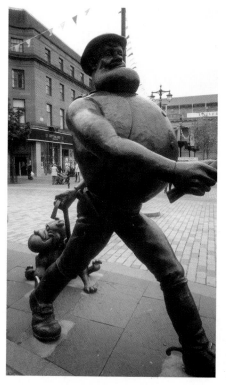

'Desperate Dan' (Tony and Susie Morrow, 2001), which stands in Dundee's High Street, is the best-known piece resulting from the city's public-art programme. The city council began to involve public artists with their environmental improvement works in 1982, since when over 120 artworks have been commissioned in Dundee.

bronze), South Gyle Crescent, was commissioned by the Royal Bank of Scotland for its headquarters at South Gyle, on the western edge of Edinburgh. In the city centre is another Paolozzi work, the gigantic bronze foot, hand and ankle that make up the *Manuscript of Monte Cassino*; it stands in front of St Mary's Roman Catholic Cathedral, facing the Picardy Place roundabout at the top end of Leith Walk (just north of the St James shopping centre). Paolozzi was born in Leith to Italian parents who came from near Monte Cassino, where monks copied, and thus preserved, many ancient texts.

West of the centre, outside the Scottish National Gallery of Modern Art, Belford Road, is *Landform Ueda* (Charles Jencks, 2002, earthwork), a grass-covered stepped, serpentine mound enclosing three crescent-shaped pools. The outdoor sculpture, which reflects Edinburgh's landscape, took two years to build and cost £380,000.

FIFE
Glenrothes
The best-known piece remaining from the public-art programme begun by the new town of Glenrothes in the late 1960s is the herd of concrete hippopotami, officially *The Witty Parade of Hippos* (Stanley Bonnar, 1972), sited at the east end of the Riverside Park off Leslie Road, on the north-west edge of the town.

NORTH LANARKSHIRE
Mossend
Standing beside the M8 at the Eurocentral rail freight terminal near Mossend is *Big Heids* (David Mach, 1999, steel), three giant heads built from welded steel sections. Each head, loosely based on a local person, stands about 10 metres (33 feet) high and is supported on a 7 metres (23 feet) high freight container. The heads were constructed by the Lanarkshire engineering firm Motherwell Bridge.

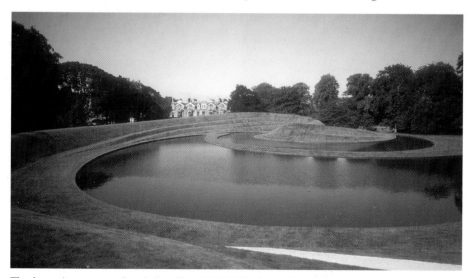

The dramatic grassy earthwork 'Landform Ueda' (Charles Jencks, 2002), which rises to a height of 7 metres (23 feet) outside the Scottish National Gallery of Modern Art, Edinburgh, is a combination of sculpture, garden and land-art. Its complex curving design was based on naturally occurring patterns and the concept of chaos theory.

WEST LOTHIAN
Bathgate

Easily seen from the M8 near Bathgate is *Sawtooth Ramps* (Patricia Leighton, 1993, earthwork), seven 11 metres (36 feet) by 44 metres (144 feet) grass-growing pyramids; the whole work is 305 metres (1001 feet) long and was the first to be carried out for the M8 Art Project. The formation of the ramps alludes to the Five Sisters, the group of red-shale spoil heaps or bings that lie about 5 km (3 miles) to the south, near West Calder.

WALES

Cardiff

One of several notable artworks sited around Cardiff Bay is *People Like Us* (John Clinch, 1993, bronze), an evocation of a young local couple and their dog, on the boardwalk at Mermaid Quay. Just to the east, near the bright-red Pierhead Building on Harbour Drive, is the *Merchant Seafarers' War Memorial* (Brian Fell, 1996), a wrecked boat transformed into a woman's face. Further along Harbour Drive is

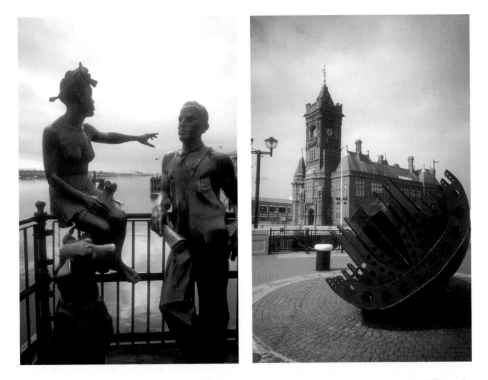

Above left: *The bronze group 'People Like Us' (1993) by John Clinch looks out over Cardiff Bay. In the same down-to-earth style is Clinch's 'Diana Dors – Film Star' (1991), which stands outside the cinema at the Shaw Ridge Leisure Complex on the west side of Swindon (off Whitehill Way). Diana Dors (1931–84) was born in Swindon.*

Above right: *Near the Welsh Assembly building on Cardiff Bay is the 'Merchant Seafarers' War Memorial' (1996) by the Derbyshire-based artist Brian Fell, whose 'Foot-plate' (1999), a 3.3 metres (11 feet) high steel rendition of a human foot, stands outside Flint railway station.*

The 'Chartist Mural' (Kenneth Budd, 1978) in Newport's John Frost Square commemorates the 1839 uprising when the Chartists, headed by John Frost, marched to the nearby Westgate Hotel and were fired upon. Kenneth Budd (1925–95) began making mosaics in the 1960s and was later joined by his son Oliver Budd; other examples of their large-scale mosaic work in Newport can be seen in the Old Green area, near the castle.

Britannia Quay, where there is a series of nine seats, the *Beastie Benches* (Gwen Heeney, 1994, carved red brick). The designs were inspired by the mythical creatures described in the Dylan Thomas poem 'Ballad of the Long-Legged Bait' and by the terracotta reliefs on the Pierhead Building.

On the northern edge of the Cardiff Bay area, just east of Atlantic Wharf, is *Landmark*, better known as the *Magic Roundabout* (Pierre Vivant, 1992), at the junction of Ocean Way and East Tyndall Street. The roundabout is capped with a jumble of large, aluminium-framed geometric forms, each bearing a colourful array of standard road signs.

Newport (see also page 20)

On the northern entrance wall of John Frost Square, centrepiece of Newport's 1970s redevelopment, is the *Chartist Mural* (Kenneth Budd, 1978, mosaic), a 37 metres (121 feet) long mural, made from around 200,000 pieces, which commemorates the 1839 Chartist uprising in Newport. Inside the Civic Centre, Godfrey Road, in the upper part of the stair hall are eleven large-scale history murals painted in 1961–4 by Hans Feibusch.

Wrexham

The façade of the Library and Arts Centre, Rhosddu Road, is decorated by the 9 metres (30 feet) by 5 metres (16 feet) Millennium tile mural *Wrexham Past and Present*, made during 1999–2000 by Penny Hampson with local artists and 1200 schoolchildren.

76

Further reading

Burstow, Robert. 'Modern sculpture in the South Bank townscape' in *Festival of Britain*, edited by Harwood and Powers. Twentieth Century Society, 2001.

Cavanagh, Terry. *Public Sculpture of Liverpool*. Liverpool University Press, 1997.

Cavanagh, Terry, and Yarrington, Alison. *Public Sculpture of Leicestershire and Rutland*. Liverpool University Press, 2000.

English Heritage. *A User's Guide to Public Sculpture*. 2000.

McKenzie, Ray. *Public Sculpture of Glasgow*. Liverpool University Press, 2002.

McKenzie, Ray. *Sculpture in Glasgow: An Illustrated Handbook*. Foulis Archive Press, 1999.

McLean, Bruce; Bauman Lyons; and Gooding, Mel. *Promenade: An Architectural Collaboration for Bridlington*. East Riding of Yorkshire Council, 2001.

Merritt, Douglas. *Sculpture in Bristol*. Redcliffe Press, 2002.

Nexus. *What Makes a Memorable Journey?* 2005. A guide to the Nexus Public Art on Transport programme, Tyne and Wear.

Northwest Regional Development Agency. *Public Art Northwest*. Carnyx Group, 2003.

Noszlopy, George T. *Public Sculpture of Birmingham*. Liverpool University Press, 1998.

Noszlopy, George T. *Public Sculpture of Warwickshire, Coventry and Solihull*. Liverpool University Press, 2003.

Noszlopy, George T., and Waterhouse, Fiona. *Public Sculpture of Staffordshire and the Black Country*. Liverpool University Press, 2005.

Pearson, Lynn. 'To brighten the environment: ceramic tile murals in Britain, 1950–70', *Journal of the Tiles and Architectural Ceramics Society*, 10 (2004), 12–17.

Public Art Commissions Agency. *Public: Art: Space*. Merrell Holberton, 1997. Describes the work of the Public Art Commissions Agency during 1987–97.

Stetter, Alex (editor). *Pride of Place: How the Lottery Contributed £1 Billion to the Arts in England*. Arts Council of England, 2002.

Usherwood, Paul; Beach, Jeremy; and Morris, Catherine. *Public Sculpture of North-East England*. Liverpool University Press, 2000.

Ward-Jackson, Philip. *Public Sculpture of the City of London*. Liverpool University Press, 2003.

Wyke, Terry, with Cocks, Harry. *Public Sculpture of Greater Manchester*. Liverpool University Press, 2004.

One of the fountain heads designed for Harlow Water Gardens by William Mitchell (born 1925), who specialised in casting concrete relief sculptures; his work was more generally seen as large-scale abstract murals. His 5 metres (16 feet) high 'Corn King and Spring Queen' (1964) are among the last remnants of the landscaping at the British Cement Association's former research centre just north-east of Slough (off Framewood Road).

Websites

Arts Council of Northern Ireland, guide to public art: www.artscouncil-
ni.org/subpages/public_art.htm
Chester Art Trail: www.chestercc.gov.uk/main.asp?page=376
Chesterfield Art Trail: www.chesterfieldarttrail.com
Cywaith Cymru – Artworks Wales: www.cywaithcymru.org
Forest of Dean Sculpture Trail: www.forestofdean-sculpture.org.uk
Irwell Sculpture Trail: www.irwellsculpturetrail.co.uk
Louth Art Trail: www.loutharttrail.info
Milton Keynes Artwalks: www.miltonkeynesartwalks.co.uk
Newcastle upon Tyne public art guide:
www.newcastle.gov.uk/artscult.nsf/a/pubartguide
Political wall murals in Northern Ireland:
www.cain.ulst.ac.uk/bibdbs/murals/index.html
Public Art Northwest: www.northwestpublicart.org.uk
Public Art Research Archive, Sheffield Hallam University: http://public-
art.shu.ac.uk
Public Art South West's resource Public Art Online: www.publicartonline.org.uk
Public Monuments and Sculpture Association: www.pmsa.org.uk
Sustrans Project Art and the Travelling Landscape: www.sustrans.org.uk

*Just inside the gates of The Hirsel Country Park, on the western edge of Coldstream in the Scottish
Borders, is a memorial to the former prime minister Sir Alec Douglas-Home (1903–95), whose family
seat was The Hirsel. The carved stone pieces, some by Angela Hunter (born 1951), centre on the bronze
statue (1998) by Bill Scott.*

Index of artists

Index of works

Index of places